DARKROOM ...WITHDRAWN

... TO DIGITAL

DARKROOM TO DIGITAL

BLACK AND WHITE PHOTOGRAPHY WITH PHOTOSHOP – THE ART OF TRANSITION

Eddie Ephraums

Argentum

First published 2004 by Argentum
an imprint of Aurum Press Ltd,
25 Bedford Avenue,
London WC1B 3AT

Reprinted 2005

A catalogue record for this book is
available from the British Library.

ISBN 1 902538 28 5

 .

Printed in China

Designed by Eddie Ephraums
Set in Stone Sans, Gothic and Arrus

'... occasionally it is decided that tradition should define the work's end result. At this point the tradition dies.'

(John Swarkowski)

Has the enlarger and its negative carrier had their day, replaced by the scanner and film holder?

... perhaps it is not the introduction of digital that is killing traditional black & white photography, but tradition itself.

Black and white lives on.

... can our images change unless we do?

Foreword

'You've come a long way young man,' I turned to tell the author jokingly, having read a few pages of this, his latest book, and at that moment I realized we both had.

I first met Eddie when I was looking for all the answers. I had come to learn about photography and the invisible face behind *The Silverprint Manual* was the one from whom I wanted to learn it. He was, to my mind, an all-knowing master and I the novice, and somehow that view of him and my place in the world was fixed, not transitory.

Life without direction soon stagnates, even the image on the retina will fade if our eyes don't move in search of fresh stimuli. Eddie and I shared this desire for illumination, in our work and lives, and yet spent all our time in a darkroom – alchemists in search of the formula.

Well, many years later, we are both to a large extent out of that darkroom as a result of a journey – the transition from darkroom to digital. The quality possible from modern technology has allowed this. But such transitions will always run parallel with a development of character. Our images cannot change unless we do … or perhaps we cannot change until our images do. My journey has been from disciple to friend, and Eddie's perhaps from technical heavyweight to creative force. But strangely in that beautiful way life has of being both simultaneously symmetrical and asymmetrical a step in friendship is automatically a step towards greater creativity and vice versa.

So in what way has the author come a long way? He has used technique to take him to a freer realm. From out-of-the-soil and down-to-earth aspects of technique, the green shoots of creativity are bearing fruit. The images in this book have a simple complexity that goes beyond earlier work and reflect a life that is more developed – a wholeness in which family, children, and work all play their part.

It has been an inward journey that allows the internal picture to become clearer and more easily projected onto the paper. This is, I believe, a process we are all involved in whether we realize it or not. As formerly rigid ideas are dismissed, our interior world surfaces and communicates less fearfully with the world around it. Spontaneity becomes the norm, and when faced with the myriad possibilities of life we can trust ourselves to do and say the appropriate thing … to operate the shutter at the appropriate moment or glide the mouse towards the appropriate Photoshop tool.

So may this book be, for you as I believe it has been for its author, one of the many transitions that take us inevitably forward both visually and creatively.

Paul Sadka

Life without direction soon stagnates, even the image on the retina will fade if our eyes don't move in search of fresh stimuli.

Contents ...

... the art of transition

Introduction

Sincerity must be a guiding principle.

I would not be true to myself or to the purposes of this book if I allowed it to become just another publication about techniques. Instead I have followed the path that the book seems to have wanted me to take. In my case, going from darkroom to digital has got me to explore what underpins any creative process.

Most, if not all, digital black and white darkroom books that I have looked at appear to concentrate on technique, demonstrating (and well, in most cases) how to achieve both traditional and new effects using Photoshop. But where are the books that explore the Whys of digital, rather than the Hows? And what about a book that explores the creative values of black and white photography in the digital age? I haven't found them.

Darkroom to Digital became my own 'coursebook' as it revealed its simple lessons to me, step-by-step, during the production process. Researching, note-making, writing, learning Photoshop, thinking about what is involved in making such a transition, and keeping a journal of it all, I came to realize that switching to digital need not be complicated (though it can be a daunting prospect). But what is complex – in all its wonderful richness – is the creative process itself.

In my case, there could be no shortcut. Simply switching to a digital darkroom would not get me any closer to that creativity, nor deeper into the heart of black and white. I had to explore why – if at all – I should make the switch to digital, and going in search of this truth is why I have chosen the subtitle, *The Art of Transition*.

Eddie Ephraums

I started out in b&w with an interest in photo-journalism and landscape. Then my photography got side-tracked by writing and publishing. With the completion of this book I feel I have come full-circle, getting in touch with what simply matters to me as a photographer, which is no longer subject specific.

About this book ... how does it work?

What are my aims for *Darkroom to Digital*?

DARKROOM TO DIGITAL
BLACK AND WHITE PHOTOGRAPHY WITH PHOTOSHOP – THE ART OF TRANSITION

Eddie Ephraums

Darkroom to Digital is intended as a companion guide. It is not for learning the Hows of Photoshop techniques. Its intention is to help ask the Whys.

A recent internet search revealed over 500 book titles with the word Photoshop in them. My intention is not to add to that list; I couldn't hope – ever – to match the technical knowledge of any of those authors, but nor do I see a need to, as I have found I can print without learning any new skills or special tricks. Instead my simple aim for this 'Photoshop' book is to share my experience of transition to digital, exploring why I made the change, and to give a few appropriately chosen details of how I created some of the pictures, and to explain why I printed them the way that I did.

I may have started this book as a digital darkroom novice, but my concern for print quality and my interest in what makes a great black and white print, enables me – I hope – to understand the concerns of other black and white photographers, perhaps like you, who are also thinking of switching to digital. For those of you who have already made the switch, and who are far more expert with Photoshop than me, then this book is an invitation to think about what else the transition to digital can *really* do for our photography. Dorothea Lange said 'the camera is an instrument that teaches people how to see without a camera' and, perhaps, Photoshop is a device that can teach us to see how a black and white print works. Spending many hours putting this book together has helped me understand more of what the art and craft of black and white is truly about; I hope it can do the same for you.

Amongst other things, creating *Darkroom to Digital* has been a great opportunity for me to reflect upon the creative values of black and white photography and to appreciate its unique, yet simple, qualities – qualities that still captivate the imagination of photographers the world over. Photoshop and other such digital darkroom software programs are extremely powerful and alluring tools, and in an ideal world our transition to digital printing should not a result of their awesome appeal. Rather it ought to be because we can see how digital will assist our own personal self-expression. In my case, Photoshop and the digital darkroom provide the means to make my photographs simpler and my printing simpler, as I will discuss later.

Each of the seven chapters opens with a double-page spread introducing one of the main themes of making the transition to a digital darkroom.

2

Traditional black & white

... what does it tell us?

A time for reflection. One of the people who fuelled my passion for silver-based labour was the renowned printer Bill Rawlinson. Here I photographed him reflecting on black and white. Why do I feel some of us lose sight of this point will be lost through a transition to digital?

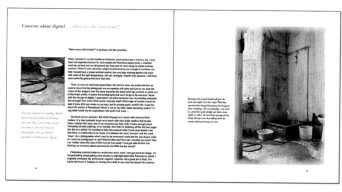

Concerns about digital ... what are the real issues?

"How soon will it fade?" is perhaps not the question.

Now my concerns are fading. Rather than worrying about permanency and such like, I am trying to pay attention to the real issues of photography that go beyond questions of darkroom or digital.

The first half of the book, prior to the Gallery, is spread-based. Each spread expands on the main theme introduced by the chapter opener.

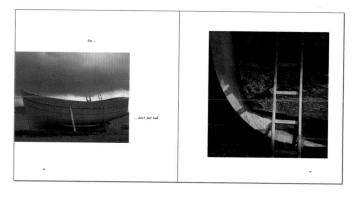

See ...

... don't just look.

The Gallery includes a selection of digitally made black and white prints produced at various stages during my transition to digital, highlighting the issue of whether we actually need to learn special digital techniques.

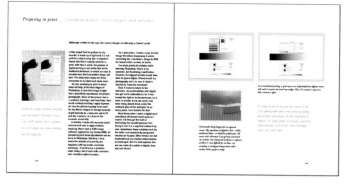

Preparing to print ... <unsharp mask>, <test strips> and mistakes

Although visible to the eye, the screen image is still only a 'latent' print.

What do I expect on heavy working and how much? Normally I use a very small amount when scanning the cvs I apply just before printing out the image file.

From then on, the book explores the more practical aspects of switching to a digital darkroom.

The photographs ... I'm no Photoshop expert

In fact, many of these prints are my first or early attempts at digital.

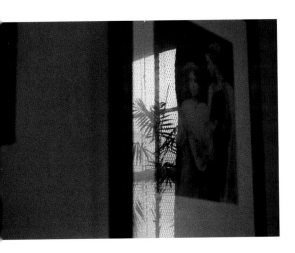

Flipped, cropped or printed full-frame. Photoshop enables us to have several versions of a print up at any one time, and to learn from each of them. Imagine trying to do that in the traditional darkroom.

Even at the outset I found it possible to get surprisingly good results on screen without really knowing anything about Photoshop, by feeling my way around in the 'dark' as it were. Fortunately, Photoshop makes it relatively easy for newcomers like me to produce black and white images, thanks to familiar darkroom tools like <dodge>, <burn> and <curves>. It can be harder though to get predictable and consistent results, especially when it comes to printing out an image to paper. In theory we need to know something about printer settings and profiles, which are covered in depth in most good technical books. However, in practice I learnt all I needed to get my one-printer-one-paper set-up working properly from the simple document that accompanies Lyson's free, downloadable small gamut ink and paper profile, and from attending a one-day colour management workshop.

Photoshop has certainly helped me understand how to print better, in a way that communicates my ideas more effectively and more powerfully than printing in the traditional darkroom ever could. Working 'blind', with latent images in the traditional darkroom, taught me to trust my judgement, to have faith in my ideas, and to realize I had developed faith as I watched the print emerge in the developer. The digital darkroom is also teaching me to have faith, this time in what I *see* before the image emerges from the printer, as I experiment with images on screen, altering their contrast and tonality, flipping them, rotating them, changing their size, altering their colour – all things I had to imagine in the past. Watching everything on screen I am learning a lot that I can take to my photography. Now I can pre-visualize an image – or look at it on my digital camera monitor – with a greater understanding of its potential and how I can bring out its hidden qualities.

All this makes me think how the grand masters of photography might have (re)approached their black and white printing if they had been fortunate enough to have access to digital. Would they have reprinted any of their pictures? Taking things further, would I go back and reprint any of my silver prints digitally? As a general rule I've always avoided reprinting earlier work in an attempt to get it looking 'better', since the crucial passion I once had for that picture – which was its key component – is likely to have passed. The exception is printing for books, when one is deliberately trying to reproduce a picture to share it with others.

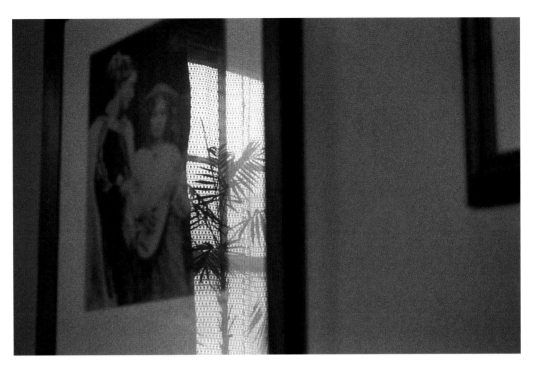

With the exception of the Gallery, *the photographs have been taken in traditional darkrooms and related workspaces. Contrary to what I first thought, the digital darkroom is not a soul-less place in which to print.*

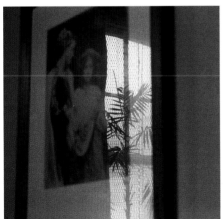

In my view a print always needs to be complete: it must be executed in such a way that it doesn't interfere with us looking at the photograph it depicts. With its potential for seamless printing, Photoshop allows us to do this better than before.

Taken a stage further, a complete print can be one that actually portrays a deliberately incomplete or ambiguous picture – one whose intention might be to unsettle the viewer or get them to think about answering questions that the image poses. But such a picture can never be well portayed by a poorly executed print.

With this in mind, my intention in printing full-frame, the version of the picture above, was to include the 'incomplete' central-right grey void and to play on it. But there is nothing to see in this area! Exactly. Constantly returning to this blank space, my eye goes off again in search of visual clues only to return again … and again.

The void is intended both to anchor the picture and to give it dynamism. My eye moves between it, the reflection of the window and the two figures.

For me the picture is suggestive of someone deep in thought, 'reflecting' on some aspect of life. This is why I chose it to lead into Chapter 1, in which we are introduced to the issues of moving from darkroom to digital. In that square-cropped version, my eyes move more simply between the two figures and the reflection. As such, it is a less ambiguous photograph, but its square shape works better within the page design and as such it doesn't compete for attention with the main heading. Also, there, the print is toned differently, again to complement the look of that page.

1

A digital darkroom

... just a room with a (new) view?

At last, with digital we can have a darkroom with a view. But how much new light does digital throw on our creative photography?

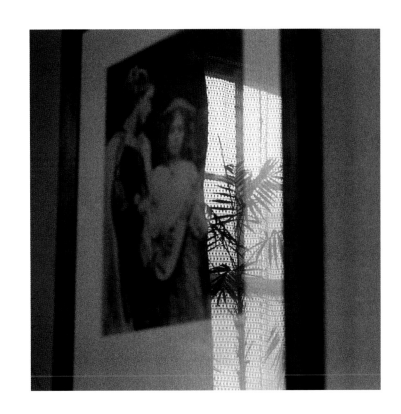

Darkroom to digital ... change for change's sake?

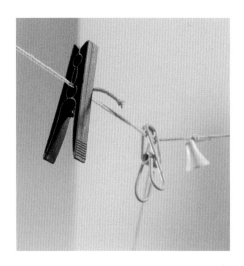

With traditional printing I had to trust my own judgement, waiting until after the print was developed before I could pull the string lightswitch and see how I'd done.

Why switch to a digital darkroom?

Time. Typically it would take me a day, at least, to make just one 20x16" traditional, exhibition-quality, toned print that I was satisfied with. As a result, I became more of a print maker and less of a photographer. This indoor way of life was somewhat ironic, given that landscape had been my main genre of photography. I want the camera – rather than the darkroom – to be capturing those precious slices of time.

Economics. The time it took me to make a traditional print meant that financially things didn't add up. Instead, it is better to supply digital picture files as more and more of my photographs are destined for magazine or book use. Copying original 20x16" prints onto colour transparency film, as I used to do, so that the image could be scanned, would now be a roundabout, fraught and expensive process. Try getting the colour and contrast right!

Reproducibility. Despite all one hears about colour-management problems, in my experience digital offers the possibility of more faithful reproduction than supplying awkward to interpret matt-surface photographic prints or transparency copies to a publisher. Now my photographs are more likely to turn out on the printed page looking the way that I made them.

Fun. There is a saying 'The test of a vocation is the love of the drudgery it involves.' I feel I have learnt all I need from the daily grind of the traditional darkroom to enable me to express myself visually in the way that I choose. Now I want to really enjoy my photography: the digital darkroom smells better, is daylit (if I so choose), and it doesn't limit my creativity by telling me when I can and can't stop for a break. With a traditional darkroom, try stopping for an hour between making a test-strip and coming back to expose the print, and tell me you can't see a difference in print density. Did the voltage drop? Has the developer started to go off ? Do my eyes need time to adjust to the darkness again?

I still love the medium of black and white; Photoshop and the digital darkroom is the way I now choose to give voice to that passion. And if something supersedes digital, then why not? My passion for black and white will remain unchanged.

Being able to work in the light is just one reason why I have switched to the more pleasant working environment of a digital darkroom.

Process to 'processor' ... is it that much of a change?

Positive or negative? Making the transition to digital has given me the chance to review my photography, to see it in a new light – for better or for worse.

Printing digitally is not about learning a new language.

It's all about transition, not translation. The art of black and white printing uses a universal language: light, shade, balance, meaning, context, rhythm, composition, contrast, depth, content, self expression ... even the craft of black and white uses much of the same vocabulary in digital as it does in the traditional darkroom. Those new terms we do have to acquire do not involve having to change our means of expression. Our language is the black and white print: dark and light shades of tone on a paper (silver, platinum, pigment or dye).

When I started this book everyone seemed technically more fluent than me. Frankly, as a digital darkroom novice I was daunted by the task of going from familiar hands-on printing to the seemingly virtual reality of a digital darkroom. Yes, I could manage extremely basic procedures in Photoshop, such as burning and dodging, and simple toning effects, but when it came to producing exhibition quality prints I was a complete beginner. My main concern was about having to learn a host of new techniques, when those offered by the traditional darkroom had, by and large, worked well for me.

To say that I wasn't in the least bit encouraged by all the confusing talk I'd heard was an understatement. For example, the need for colour calibration and paper profiling, not to mention all the contradictory views on image permanence and the supposed merits of one ink system over another. And was it really going to be necessary to learn all those new techniques like <layers> and <paths>?

What encouraged me most in my journey into the 'virtual' unknown was the reminder that I had been 'there' before. If I had taught myself traditional techniques, then why not digital? As for my concerns about equipment: some of my best silver prints were made using a very basic enlarger and simple printing techniques. Could the same level of simplicity still apply? Or would I need to invest heavily in expensive gear? What had counted back then was the vision I had for a particular image and I was sure the same must still be true for digital.

My intention always was – and still is – to be true to my photography and not get sucked into learning a myriad different techniques, just for technique's sake.

Digital is not totally foreign to us, since many terms remain unchanged: 'dodge', 'burn' and 'curves', to name but three. 'Development' and 'fixing' seem to have been lost. For the better?

Concerns about digital ... what are the real issues?

"How soon will it fade?" is perhaps not the question.

Now my concerns are fading. Rather than worrying about permanency and such like, I am trying to pay attention to the real issues of photography that go beyond questions of darkroom or digital.

When I printed in my first traditional darkroom, permanency was a concern too. I may have had separate washers for resin-coated and fibre-base papers (well, a modified washing up bowl and an old shower) but they were far from being so-called archival washers. What I'd read about the subject of permanency was enough to convince me that I should have a proper archival washer, also use hypo clearing agents and wash with water of the right temperature. And yet, strangely, despite their absence, I still have some perfectly good prints from that time.

Then, as now, we want such guarantees. We want to know our prints will last; we want to know that the photograph we pre-visualize will come out just so; we want the colour of the image to look the same way after the toned print has air-dried or come out of the inkjet printer. It seems that photography just can't let go of its concerns. Faced with the change to digital, I experienced yet more concerns: was my exisiting computer fast enough? How much RAM would I actually need? Which type of monitor would be best (I knew LCD was kinder on my eyes, but for photographic work?)? Did I need the latest CS version of Photoshop? Would it run on my older Apple operating system? If I upgraded would my old applications still work? And more ...

Concerns serve a purpose. But whilst they get us in touch with what we think matters, it is their potential to get us in touch with what *really* matters that counts. When I started this book, one of my concerns was that I didn't know enough about Photoshop (hardly anything, to be honest). Now that I'm finishing off the last few pages like this one (which I'm rewriting to take into account what I have since learnt) I see that there is a distinction to be made: it is between the word 'concern' and the word 'issue'. As a photographer what I need to be concerned about are the real *issues*: what do I want my photographs to say? What do they say? How can I develop my vision? How can I better share this view of life? And yet how easily I have got side-tracked into thinking my concerns about permanency and RAM are the issues?

Photoshop certainly helps me realize how much more I can get out of an image. I'm not just talking about getting extra shadow or highlight detail (the Promicrol in which I originally developed the printwasher negative, opposite, did a good job of that). The digital darkroom is helping me develop the ability to see what lies beyond the obvious.

Burning in the central shaded wall gives the print more depth. Even this simple Photoshop experiment has changed the picture from being just about something – the issue of fading – and made it a print that speaks of light and shade, about 'depth' as well as the more linear passage of time. Surely this says more than talking about my concerns about permanency ever can.

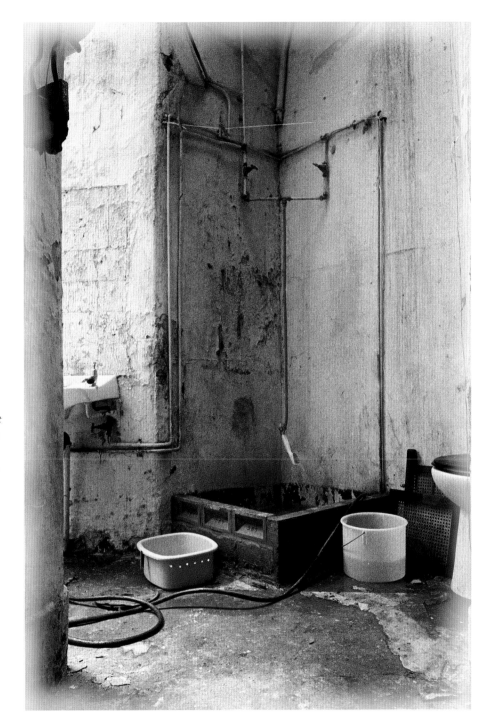

Traditional black & white

... what does it tell us?

A time for reflection. One of the people who fuelled my passion for silver-based b&w was the renowned printer Bill Rowlinson. Here I photographed him reflecting on black and white. Why do (did?) some of us fear its power will be lost through a transition to digital?

Develop a way of seeing ... *independent of technique*

Of course, I still want to produce good negatives, although I can get respectable looking prints from scans of very poorly exposed and badly developed film.

Seeing is no different with digital.

How would it be to photograph with an innocent eye? To be able to get back to where I started from before I learnt how I 'ought' to make photographs? This state of innocence is one that some highly practised and talented photographers have managed to reach, and which others like myself simply aspire to.

A few years ago I recognized how far I still had to go on this journey when I found myself reading an old photocopied article pinned to a notice board. This was while I was waiting for some workshop students to come out of the darkroom. The article rather annoyed me: not only did the author know a lot more about black and white than me, he also wrote better than I did. The only consolation was that his pictures weren't much good. Imagine then my surprise when I got to the end of the piece and found my own name appended to it. I had written THAT article and made THOSE photographs. What was worse? Not remembering I had written it? Being annoyed the author knew more than me? Or the very average quality of the pictures?

But there was consolation to be had. Whilst the photographs disappointed me, I soon came to appreciate that perhaps this incident was evidence that I was letting go of what I had painstakenly learnt about all the various black and white techniques. Had the time therefore arrived when I was ready to concentrate on the simple matter of making images? If so, then the lesson to be learnt (relearnt?) now is that I should not fall into the trap of thinking I should know all I can about digital. Instead, my time would be best spent exploring the way I see and developing a better understanding of what influences and guides that vision. Which is ...?

The way I see photographically is changing largely because of the way I intend to display my photographs in the future. In the past, the individual image was the thing, as I hoped to sell single images through exhibitions to individuals wanting a piece of art to hang on their walls. Now as I explore the potential of showing my work in books I'm thinking more about how photographs work when they are grouped together and put into a sequence. This is testing me to develop complementary skills, like book design and page layout.

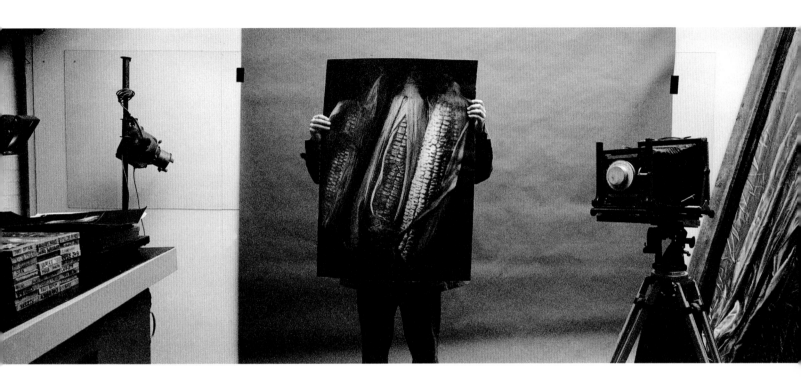

Most important is the photographer behind the print and
his or her unique way of seeing.

Individuality counts ... *we are the vital ingredient*

Already it seems like a long time ago that I was mixing up chemicals and forever on the lookout for new formulae to try out. Thankfully software upgrades don't have quite the same appeal.

Chemistry or formula?

With digital we are entering an era in which there are no chemical formulae, but the importance of personal chemistry – our creative relationship with photography – remains. Or does it? Now we can press the shutter release button without having to think about what we are doing and rely upon the digital camera screen and our reaction to it to decide whether an image is good or not.

There may be no need to worry about this, but I have noticed how, with a digital camera, I tend to react to the LCD image, using it to judge my photography *after* I have made the exposure, rather than relying on what I feel *before* I press the shutter release button to guide me. Too often this approach encourages me to delete what might actually be useable images, had I given them the benefit of further reflection. Perhaps there is nothing wrong with this *after* method? Maybe this actually gives b&w a new edge. Perhaps being able to review the image immediately post-exposure enables us to see the image really for what it is, rather than as we imagine it to be. Think about how often have we lost the plot with the lengthy traditional darkroom approach, which involves the processes of developing film, making contact sheets, then proof prints, and finally exhibition prints, before we see a result. After all this time we can become so attached to our idea of what we *think* the picture is saying that we don't see it for what it really is. Photographers who have always worked with colour transparency, or who have used Polaroid, won't have experienced this time-delay problem. The first time they see their photograph, it is not in a semi-finished, negative state, but positive and complete. But what does this do for developing visual awareness and confidence – can these only come from within?

The idea of relying on the digital camera's review facility and living without the need for 'inner images' prompts some further questioning: in my own case, what am I left with if I strip away my one-time reputation for b&w techniques, or for being a landscape photographer, or for writing articles and publishing books? What do I discover? What then does the inner image portray? Interestingly, I note that my photography has shifted in content quite noticeably over the last few years. I no longer go in search of landscapes, instead I tend to photograph in and around the house, turning my lens on the familiar to see what I can discover, and more often than before what I see comes from an awareness of how I feel – at home. Is this the inner image at work?

*Traditional or digital, individually we already possess
what's really necessary for creative success. Perhaps the
time has already come to switch off the digital camera
monitor and go with the flow, as before?*

Photography is our voice ... what do we want to say?

The camera format and the focal length of the lens we choose have a significant bearing upon the overall meaning of a photograph. Darkroom techniques – whether traditional or digital – help clarify and refine that meaning.

What do I choose to communicate?

A friend emailed me her photographic mission statement, which she had written for an exhibition in the United States. Would I edit it for her? I replied: ' ... began editing your mission statement – not that it needs it – and found myself starting to write something for myself. Talk about a Freudian slip: when I typed in the words "Ed's mission statement" what I actually wrote was "Ed's missin statement" by mistake. Perhaps missin' sums up why my photography came to a bit of standstill for so long.'

This is what I then wrote:

'Film or data card, a camera is an invitation to see the world differently and to experience it through an enhanced, focused state of awareness. At a basic level photography's purpose is to challenge the daily continuum of life, breaking it down into individual experiences and revelations that we as photographers celebrate and want to share visually through the magic of the print.

'My own photography seeks to go beyond this. Its aim is more than simply to report what is there or merely to share what I have experienced. Through images that pose questions and elicit responses, its intention is to intrigue and then to stimulate the viewer into having visual experiences of their own. In this way a landscape that could be represented pictorially, instead might become the tranquil focus for a meditation; a picture of a stranded and decaying boat might become the starting point for a new kind of voyage of discovery; an image of a studio photographer gracefully at work could be seen as a practitioner of tai-chi, enabling us to reflect on our own daily practice of photography and how it can be seen in a fresh light.

'Those old pictures of mine which still have a place in my heart, which still contain undiscovered elements waiting for me to appreciate, have also tended to be the ones that others are drawn to. It is the same undiscovered quality that I appreciate in the photographs of others. They achieve their place of favour by trying to be as economical as possible, by saying less rather than more, by avoiding the use of description and going for inference instead.'

I have no favoured subjects, although there are people
and places I am drawn towards. Typically they are more
quiet than loud, yet with plenty to say – and a
willingness to share.

How we print is important ... it gets our message across

The process of printing b&w may no longer be chemically based, but this doesn't affect how we print. Our way of seeing is not based on process or technique.

Should a photograph be self-explanatory?

It seems to me that some galleries, certain photographic curators and various critics believe that, if they are to be worthy of merit, photographs and exhibitions have to be complicated, and in some way inaccessible to the ordinary viewer. This opinion is reinforced by the way such people write about photographs: I find their arguments are difficult to follow and confusing, and they often seem to be at odds with what the print in question is actually saying to me.

The mistake being made here is possibly quite simple: rather trying to be *complicated*, perhaps we should aspire to *complexity*. It is 'the result of two broad psychological processes: differentiation and integration. Differentiation implies a movement towards uniqueness, toward separating oneself from others. Integration refers to its opposite; a union with other people, with ideas and entities beyond the self. A complex self is one that succeeds in combining these opposite tendencies.' Differentiation and integration are essential to both the photographer and the print if either is to be successful in achieving their goal.

One of the keys to demonstrating complexity is the style in which we print our photographs. Yes, it needs to be unique, but it also needs to speak a language that everyone can understand. For this to happen, the photographer needs to convey their originality using a grammar that gives clarity to the meaning of the picture: in a pictorial landscape, empty white skies, made up solely of paper-base white, are not empty skies at all but blank spaces in the jigsaw puzzle; totally black shadows can fall into the same trap. Of course if the picture intends to play a game with our perception of the land, then it must do so in a way that makes this clear. A picture of an incomplete jigsaw puzzle is one thing, but not giving someone all the pieces creates confusion and the photographer's intention remains unclear.

Just recently, at the first ever Photo London show, I saw three prints by the same photographer that demonstrated perfectly how complexity can be achieved. They were small, exquisite still-life platinum prints by Tomio Seike. Apparently the photographer prints for himself and it showed.

Some of the prints in this book were made with very little understanding of Photoshop and quite basic equipment, and others were made in a traditional darkroom. Does it matter which ones?

Printing is an art ... maybe the art of letting go

How do we transcend technique?

As we know, meditation can take many forms other than in a darkened room with a single, lit candle. The darkroom, with its dim red safelight, also creates the perfect environment in which to lose all sense of outside awareness: a place to focus – silently – just on the print.

The ability to totally connect with the task in hand is essential if we are to attain the genuine satisfaction that comes with doing something to its utmost potential. How can we expect a black and white print to speak to us if, in its making, we are not fully attentive to it? Yet my experience of teaching traditional b&w is that some people are not comfortable with this silence, let alone the inner silence of the darkroom. For them distraction seems to be an essential part of life, but its rewards are none too clear to me. Similarly, I recall trying to teach someone to sail a dinghy and since it was clear she was looking everywhere but where she wanted to go, I suggested she close her eyes and feel for the wind on the back of her neck as we ran before it coming over the starboard quarter. The effect was utterly miraculous. In an instant, this novice helms-person was transformed into a seasoned skipper. With every subtle shift of wind direction she instinctively moved the tiller this way or that so the sails stayed full and the course remained true, on this most difficult point of sailing.

How often have I left the traditional darkroom in such an absorbed state that it was a complete surprise to find night had long since replaced the expected day?

I'm still in my digital infancy and none too confident about closing my eyes to put my faith in the wind of change. That said, there are times when I switch off the computer screen as I type an article (to stop myself from being distracted by reading what I've just written – rather than focusing on what I want next to say). It's an uncomfortable experience knowing that there is something going on to which I am no longer party to, but after a minute or two the discomfort is replaced by a sense of excitement: what will the text read like when it is finished? Surely this is akin to the magic of waiting for the latent image to appear in the developer.

Certainly the tools of black and white are transferable to the digital darkroom, but what needs identifying is the type of meditation that digital can engage us in. I'm all too aware of the distractions that the computer darkroom confronts us with, as many double up as a video games arcade, an internet café, an office, and a concert hall.

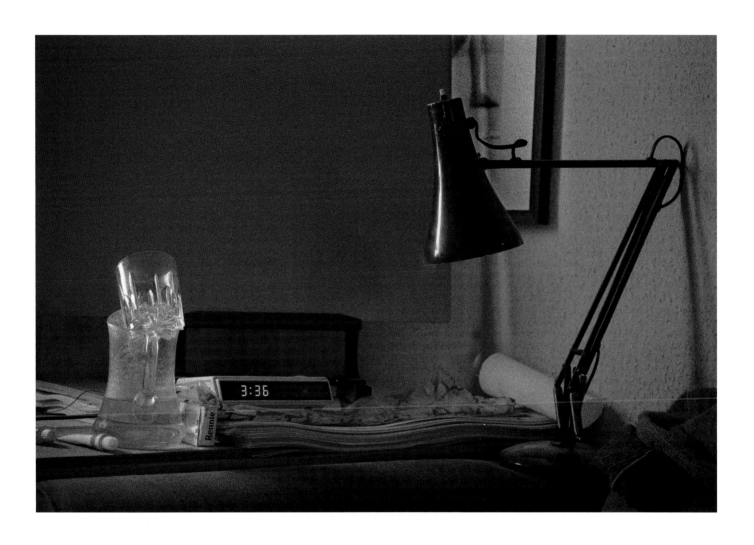

I have a computer dedicated exclusively to photography in its room where the blinds can be drawn for consistent colour management (and those all-important power naps).

Black and white ... an intuitive process

Should we print by nature or by design?

With Photoshop we have the potential to endlessly refine a print. This can result in taking things too far. I tried to get the front cover image looking so perfect that it lost all the raw spontaniety of my original quickly made guide print (above left). In every sense, such mistakes can be costly.

Consider the following: my first attempt at digitally printing the front cover image of this book was my best. Unselfconscious and fluid, it was more in keeping with how I originally responded to the subject. However, my approach to printing the picture completely changed after I decided to use it on the cover, having worked out the design for the book for which it was well suited. In reprinting it, my approach became self-conscious and laboured (after all, this was to be a show-case image and it had to look just right), so I thought the structure and content of the picture ought to be made more obvious – to work with the design, for more dramatic effect.

I was sure this planned, methodical approach would work, that is until I got a cover proof back from the printers. My immediate response was one of shock. The reprint just didn't look right, especially when integrated into a book jacket. Worse still was that these proofs were going to be used by the trade reps to sell the book – MY book. Was pride was at stake here? I had failed to get it right ... on this, a book *about* black & white.

When I discussed the situation with my gifted photographer friend Paul Sadka, he, too, agreed that I should revert to the earlier, more freely printed version. Why? It was Paul who said that the reprint was self-consciously about design, whereas my earlier print was something altogether more natural (more photographic?). He mentioned something else: in his view a potential problem with digital is that it offers us infinite potential for endless refinement (meddling with a print?). How, then, do we say when a print looks right, when enough 'meddling' is enough?

I developed my feeling for traditional black and white printing through much practice, experimentation and observation, looking back at old prints and studying partially worked proof images. What has surprised me about digital is that with practice this feeling approach now seems just as present. I wouldn't have thought this possible before I printed digitally, but after a year spent working on this book, doing battle with computers and operating system upgrades, I now find fluency has indeed made space for feeling.

DARKROOM TO DIGITAL
Eddie Ephraums

DARKROOM TO DIGITAL
BLACK AND WHITE PHOTOGRAPHY WITH PHOTOSHOP – THE ART OF TRANSITION

Eddie Ephraums

Augustus

Opposite, far left. The tap's shadow is not trying to be the focus of attention – rather it leads the eye into the subject (the tap itself) and from there my gaze travels up to the right, where the brightness creates a sense of expectancy inviting me to look beyond the frame, to where the light is – perhaps to what's inside the book? 'Turn over and see', I would like the print to say.

Opposite, near left and above. In my failed version (which I suspect might actually look rather better reproduced here, small), I separated the tap's shadow from the shaded area that it originally bled into. The problem was this made the shadow too bold and in no way is its shape as beautiful as the tap itself. Brightening the area around the shadow also meant that the wire no longer floated above its previously dark backdrop. The result is a rather obvious, self-contained print that looks two- rather than three-dimensional. Having spent so many years printing black and white it was sobering to have got it so wrong.

Other mistakes I made? The colour of my over-worked print wasn't right. My original <tritone> version had blue-grey shadows and warm highlights. These were the perfect compliment for the orange word 'Digital'. What worked though was the spine. I had extended the central shadow to cover it. In this way 'Digital' would stand out well on any bookshelf.

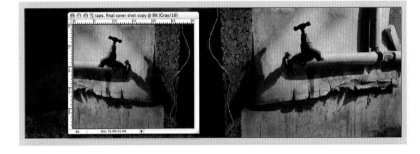

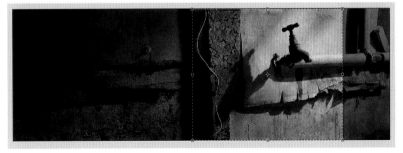

Above. A flipped image and an unapplied crop, masking all but the front cover, were useful for checking the balance of the cover.

41

Pre-visualise the print ... and still with Photoshop?

How does the digital darkroom help us develop our vision?

Photoshop makes visible all the stages of black and white print-making. Tools like <histogram>, <curves>, <levels> and <duotone> enable us to see what will happen if we alter the tonal range of a picture, when we change print contrast, alter brightness or tone a print.

To borrow a well-known saying, 'Discovery makes us understand, but only Art makes us marvel.' Photoshop can do a lot to help us understand the way black and white photography works, but it can't make us marvel; only we – still – have the power to do that.

In photography it might seem that we frame our subject with the viewfinder, then with the enlarger easel or computer screen, and finally with a picture frame. But should we think in such contained terms? Just as the camera viewfinder is often described as either a window or a mirror, so the computer screen could be considered an easel and, rather than containing the print, a picture frame might be said to set a picture free from its surroundings. Our own photography is likely to fail if we use any method – traditional or digital – to contain an image.

One of Photoshop's greatest assets is its ability to make a duplicate image (at the click of a mouse) that we can play with, perhaps by cropping it, while comparing it on screen to the original. In the book you will find some examples of such images within images: details taken from full-frame photographs, with both the original and the cropped, flipped or rotated version. My thinking behind this is to show how with digital we can learn more about the way that the message and interpretation of a picture changes with how we compose, crop and/or balance it. Generally speaking, I would say that full-frame images tend to have stronger narrative content, and are more easily read, while cropped, abstract versions are more ambiguous and possess intrigue. Which is better? That depends on our intention for the picture and how we wish to display it: individually, or as part of a picture spread.

There are several stages we must pass through on the way to mastering the art of black and white, whether printing traditionally or digitally: i) naivety and intention (at the outset, our enthusiasm is necessary to overcome concerns about not getting it right); ii) struggle (for every ten units of effort we put in, we may get just a single one in return); iii) competency (we start seeing results); iv) fluency (results happen without us even having to think about them); v) conversation (our prints begin to say something about our subject and about us); and vi) dialogue (our photographs generate a response which feeds back into our photography). What stage am I at? Well, I started the book very much at stage i) (full of naivety and intention and plenty of fear) and now as I reach its conclusion I find that rather than struggling, or not feeling in control, I am able to print without really thinking about it (puts me at stage iv?). What has helped me most in my transition towards hoped-for mastery of digital black and white is focusing my printing on just those tradition-based methods I am familiar with – and no more.

In the past, making individual prints to frame was my usual objective. Now that I work more towards making books, my approach to printing black and white has changed. I see pictures more in terms of sets, or narrative sequences, in which each image plays an orchestrated part. To get the prints to work together, they need to be finely balanced – a job which Photoshop helps me do better than ever before.

The tools of black & white

... and their Photoshop equivalents

From clothes peg to jpeg.

In the traditional darkroom I used wooden pegs for all sorts of purposes: hanging up film to air-dry, re-aligning my old diffuser enlarger, sealing up bags of chemicals, and keeping the black-out curtain pegged open when printing was over for the day. Today's jpeg seems to be just as ubiquitous.

Traditional darkroom tools ... *simple but effective*

A pair of scissors and sheets of flexible card, to make traditional printing masks, seem primitive by today's <quick mask> standards.

Instinct and experience.

I'm still amazed by what can be achieved with a dodger made from a bit of black card stuck to a florist's wire, waved over a sheet of light sensitive paper, or with a ball of cotton wool, dunked in Farmers reducer, and rubbed over a freshly fixed print. And just as I will never be able to get my head around how a computer works, so I will never be able to *really* explain how to dodge a print – everyone has their own well-practised method; nor will I be able to say when enough bleaching with Farmer's is *enough*, other than to say one instinctively knows when the application is right. It feels, well, just right. Oh yes, and it looks good too!

The marvel of traditional black and white lies in its simplicity. Ten years ago I wrote a whole book based on using just one darkroom tool – variable contrast paper. Yet even when the book was finished I knew it still wasn't complete. There were new levels of mastery to be achieved. In contrast, now with digital, single books are dedicated to vast numbers of tools and different techniques, to the extent that most leave me as confused as when I started, if not more so. The limited range of traditional black and white tools did a lot for the medium's success, not unlike Ford's 'choice' of black-only cars. The advantage of photography is that it offers white as well as black, and of course a whole range of grey tones in between (256 in 8-bit mode, so my computer tells me).

The art of simplicity was amply demonstrated to me over a decade ago when I followed a Citroen 2CV, identical to my own, down a winding mountain road littered with hairpin bends. At every corner the inside rear wheel of that car lifted clean off the tarmac. The driver must be insane, I thought, as he appeared to throw the car round one corner after another. How could a vehicle as simple as the humble Deux Cheveux do this? Did the secret lie in the confident hands of the driver? Then I realized that in keeping up with his car, mine must be doing exactly the same, but I was not an expert driver ... and with this thought self-consciousness crept in. I took my foot off the pedal.

By the end of my time with traditional b&w I had gained the confidence to work simply and unselfconsciously with just two film types (running on two wheels?), with one film developer for each (C-41 for XP2 Super and Gordon Hutchins' PMK for the Delta 3200), one enlarger (with a Mutligrade head), one paper (Ilford Multigrade matt), a standard print developer, and basic archival toners – not forgetting card, scissors and dodgers.

In the traditional darkroom, a dodger was the equivalent of a lead violinist's bow. Photoshop gives the added control of a conductor's baton.

Photoshop tools ... which ones?

Do we need more advanced tools like <layers>?

Throughout the making of this book doubt has been my constant companion. From the outset I couldn't help but think that I ought to learn everything about Photoshop and then, and only then, begin the writing process. Coming from a perspective of nervous ignorance did not seem like the best way to help others like me to make the transition to digital. Now I think otherwise.

Photoshop has all sorts of tools that traditional darkroom workers will be familiar with and plenty of new ones as well, like <layers>. But even at this stage of transition, I am still committed to keeping things simple: to use the tools I'm familiar with (burn, dodge, contrast control, masking and toning, etc). I hope the results in this book speak well for this simple approach. It is one I would advocate to anyone making the switch to digital. Perhaps we should all go back to using the basic Photoshop Elements.

I see my new G5 computer as the Leitz Focomat enlarger I never owned. A mixture of workhorse and pedigree thoroughbred, it possesses all that I need to get on with the job reliably and with good speed – but not haste. Of course any enlarger is only as good as its lens, the evenness of its light source and its ability to hold the negative perfectly flat and parallel with both the lens-stage and baseboard. What price are we prepared to pay for this? For those like me who still prefer to use film, a scanner is the equivalent of the enlarger, its lens and negative holder. Just as with these traditional tools, there are acceptably good scanners and then there are those gems that engender such confidence that we can devote ourselves entirely to the creative job in hand and leave the scanner to perform its job.

There are some excellent flatbed scanners on the market and at ridiculously cheap prices. But when it comes to producing the ultimate quality, and consistently so, they can't be expected to compete with bespoke film scanners like Imacon's Flextight 646. But would I be totally mad to spend 20 times more on this piece of equipment? Working as I am in the combined fields of photography and book publishing, in which my aim is to achieve the best, there can be only one answer. The Imacon has an unusual upright, tapered box shape, under which is hidden a combination of traditional enlarger optics and digital (CCD) technology. As a scanner it is superb, and worthy of the price-tag, but as a piece of sculpture symbolizing a mixed marriage of technologies, it is worth more.

Faster printing times with digital give me time to enjoy other pleasures. With my new-found spare time, it seems right to add a garden chair to my digital shopping list.

I used almost identical digital printing techniques for both these images, yet no amount of digital darkroom work can disguise the fact that one of them clearly lacks passion. There is still no substitute for the 'right' light.

4

My approach to printing

... a search for simplicity

What role formulae now?

Chemicals aside, do we slavishly print to a set of rules or let each picture determine our approach to printing?

Learn it ... then forget it

The blank canvas.

FOREWORD

BLANK AND WHITE

IT WAS TOM'S FIRST BRUSH WITH MODERNISM

Back in 1990 I co-wrote the b&w Silverprint Manual with Martin Reed. In Tom Ang's Foreword, it was the blank sheet of photographic paper that confronted photographers. Now that we have the blank canvas of digital to deal with, the Baxter cartoon that illustrated that piece seems even more apt than before.

In *Creative Elements – Landscape Photography & Darkroom Techniques*, I wrote over 100,000 words. Of these I can only remember a few, and they are in the Introduction where I talked about the importance of the light from the enlarger and our control over it. Now that the enlarger is gone, it is somewhat ironic that in a recent reprint the printers made a mistake and omitted the text from that very page, leaving one final blank sheet of paper for traditional photographers to ponder over.

How would I fill that space now? With words? Or would I let an image do the talking? Or maybe I would leave it blank as a homage to the latent image. The same simple question arises again here today. 'Does anything need to be said on this page?' What if we've read enough in the many photographic books that already exist, to enable us to make great pictures? What is left to be said?

As a photographer and black and white print maker I feel comfortable when confronted by a blank sheet of paper, as long as it is the light-sensitive or photographic ink-receptive variety, and not the sort that begs to be filled with words, as this text page implies I ought. Perhaps the difference here is that I still feel I'm learning the craft of writing, and hence the words seem self-conscious and ponderous, not helped by my less than fluid typing skills. All too often I fall into the trap of trying to learn more about how to write, in the hope that this knowledge will enable me to move forward, to overcome the blocks, self-consciousness and nagging doubts that writers suffer. As with any process, there comes a critical point when extra techniques won't help.

Darkroom to Digital is not about being led by technology or techniques, but of going back to our 'original' eye, like those always perfect, pre-learned compositions of early childhood. As such, it is not a book about how to achieve such a state, but why, and when to use certain tools and when not to. My intention is to keep the focus on self-expression. It's distracting enough to move from one darkroom to another without having to learn new tools and techniques.

Ironically, a traditional f.stop print exposure table, copied onto transparency film for slide lectures, and put into (now permanent) storage, has suffered from more than the introduction of digital. Archival storage problems, and future retrieval of image files, are concerns that affect digital photography as well.

My traditional practice ... *an intuitive way of working*

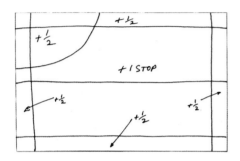

Often I am surprised at the distancing effect that time has had upon my appreciation for a print. Later I can't see why I bothered making ever more refined prints with the aid of all my detailed printing diagrams, when the first print may now look the best.

Beyond logic?

Believe it or not, the notes on the opposite page show my 'ordered' approach to printing traditional 20x16" exhibition prints. Only after the diagrams were put together, using the results from various intuitive proof prints and many calculated test-strips, would I be ready to make 'the' print, to create it printing by numbers (diagram on this page).

On the one hand working intuitively seems rather hit and miss – unfocused, even; on the other hand printing a photograph by numbers seems rather clinical and artless. If I knew that other photographers printed 'the' final print in the same ordered way, and if I wanted to purchase one of their original images, would I rather buy one of their intuitive (more original?) proof prints? Or would I go for the 'mechanical' (coldly?) printed, final version? It varies: I love to connect with the workings of a photographer's mind (as seen in rough proofs), but I also love the way a beautifully executed print becomes almost as invisible as a flawless window on that photographer's world. Print collectors tend to go for the former, paying higher prices for an original photograph printed at or nearer the time the negative was made, even though subsequent prints might show a more refined and better developed sense of what the picture is actually about.

While hosting a workshop some years ago it became clear that one of the students wanted to purchase a print of mine. There was a problem. This wasn't just any print. It was one of my hardest to print images, whose colour was the product of an impossible to reproduce combination of toners. It was a one-off; I knew that I couldn't repeat it. What should I do? Eventually I agreed a price that made it worthwhile for the print and myself to part company. 'I'll take the photograph back to London and make a new window mount for it,' I said. 'Give me your address and I'll post it to you.' The new owner agreed.

Prior to posting the photograph, I pulled out the only other two prints of the same image. The difference between them and the 'better' one was simply in my subjective interpretation of the negative: one was slightly darker, the other a little brighter, and balanced differently. All three were processed to the same archival standard. Then an idea came to me. Might the new owner prefer one of the other prints? Why didn't I keep my 'better' print? A few days later a letter dropped onto the doormat. I recognized the postmark; very sheepishly, I opened the envelope, expecting an irate note to be inside. On the contrary: '... thank you so much. The print is even better than I remember it.'

My digital practice ... more of the same?

Everything has changed – nothing has changed.

At this stage of transition I don't work with more advanced techniques like <layers>. I have no need – I'm getting the results I want.

As with traditional printing, much of my best digital darkroom work happens when I have a play at it, say when dinner is just a couple of short minutes away. With a click of the mouse here, a drag of the cursor there, and some dodging and burning at uncontrollably high percentages, the print often looks just great – a truly 'RAW' digital image, as it were. After the break for food I might revisit the image with the intention of printing it properly, but doesn't it look just fine as it is?

Play is an important part of any artistic endeavour. And having fun is a big part of what photography is all about. In the book *What's Missing?* (published as *Creative Exposures* in the USA), I asked photographers whether they ever laughed in the darkroom. Surprisingly few said yes. Continuing this theme, I have an unattributed quote in one of my notebooks; it tells me 'Aristotle concluded that, more than anything else, men and women seek happiness. While happiness itself is sought for its own sake, every other goal – health, beauty, money, or power – is valued only because we expect that it will make us happy.' I'm sure he would add Photoshop to the list.

How much do I expect Digital to make me happy about my photography? And in particular working with Photoshop? Is it the freedom to stop mid-print when I suddenly remember that the plants desperately need watering? (And then to be visually inspired by nature's constant surprises.) Many artists have derived their ideas from the 'same' such happen-stance; why not digital darkroom practitioners as well? In many respects, printing black and white photographs with Photoshop is so similar to the traditional darkroom method and yet also it is so different. Did I ever go back to the burn and dodge of the darkroom still wearing my garden sun hat?

Of course everything has to start somewhere. And as there are no true shortcuts on the path to simplicity and self-expression, and with the pre-dinner lesson of spontaneous printing in mind, I can say that I have developed a simple working practice for Photoshop. I will expand upon it in chapter 7. Suffice it to say, it goes something like this: open scanned RGB image or RAW file> desaturate> dodge and burn> quick mask (if necessary)> curves> rubber stamp> convert to 8-bit greyscale> duotone> duplicate back-up file> unsharp mask> print> archive image file. Was traditional black and white any simpler?

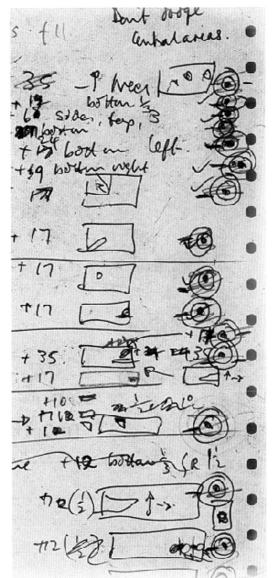

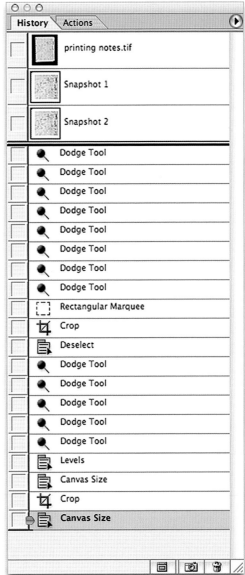

Then and now. Under the safelight my printing notes were written unselfconsciously, in a haphazard, mind-mapping kind of way. With Photoshop the printing process might seem to be rather linear and perhaps too logical in its approach, but actually not. Now I find that I experiment more than ever before, and I always have <history> to tell me what happened when something works out well.

5

A gallery

... digital printing in practice

Putting our stamp on it.
After I put trepidation to one side, and started to play with Photoshop, I realized how much fun digital printing could be, especially as I began to put my mark on it.

Beyond technique ... my guiding principles

My guiding principles are not concerned with processes. Rather they help me see what I am looking at, both at the camera and the printing stage.

A search for simplicity.

The pictures in this gallery have all been taken at the water's edge. At first glance they may seem like an eclectic mixture of boats, post, fishing nets, boatyards and boulders, taken in locations as diverse as Brittany, Essex and the Orkney Islands, using both film and digital cameras, but for me (at least) there is something that unites them ... I've moved on. And in a number of ways.

Gone are the pictorial landscapes. And gone with them is the time-consuming darkroom work that went with that style of work, as I tried to simplify the content of each print to attain a 'precision of feeling'. This search for precision involved trying to eliminate all the unwanted information that nature decided she wanted to include in my pictures. It was slow work printing that way and I rarely achieved what I visualized, although, to be fair, it would never be easy using primitive, traditional dodging, burning and bleaching tools. But I learnt so much about how to use these tools (and from using them) that I can take with me into the digital darkroom, as they also exist in Photoshop. Now with Photoshop I can see what I'm achieving, and the digital versions of these tools are far more accurate and potentially more subtle or dramatic, whichever I prefer.

The pictures here represent a move towards more precise, intimate and simpler imagery. At the same time, because I've been fortunate enough to design the book myself, I have been able to put these pictures into context, sequencing and pairing them in ways that draw on their similarities or play on their differences, or which give them a deliberate narrative dimension.

Books are the way that I want to take my photography forward. My experience of commissioning and designing publications for Argentum has convinced me of the power of the narrative statement in which images no longer seek individual attention, but aim to work as part of a set. This requires much greater attention to printing, and the ability to match prints, for which Photoshop and particularly the <info> tool are ideally suited.

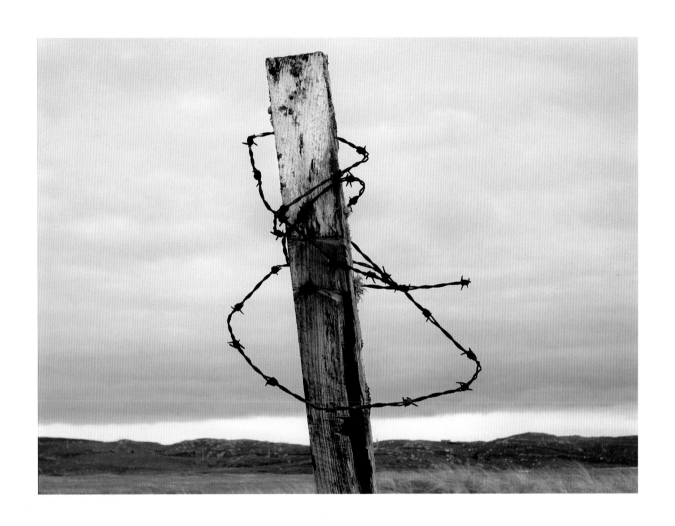

Order out of chaos.

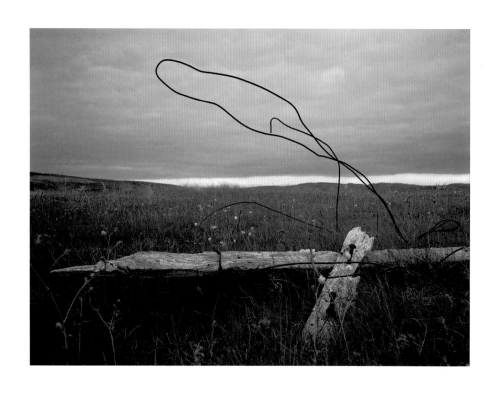

A precision of feeling.

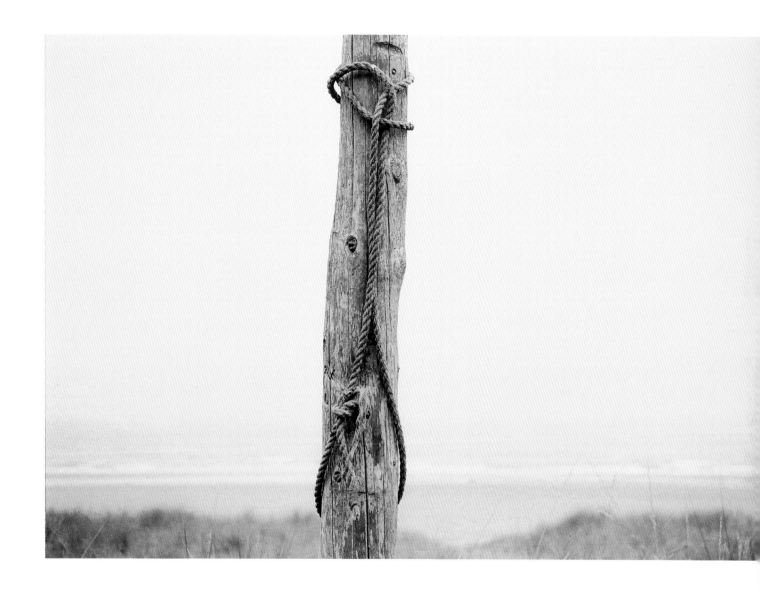

Ambiguous or obvious?

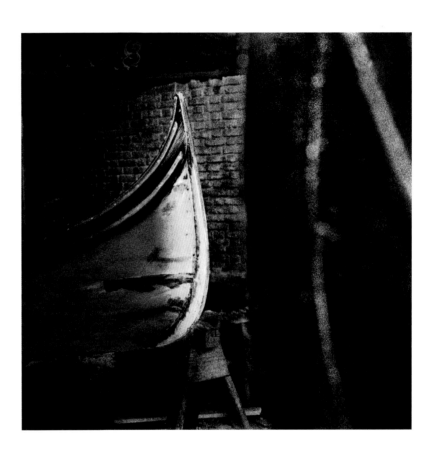

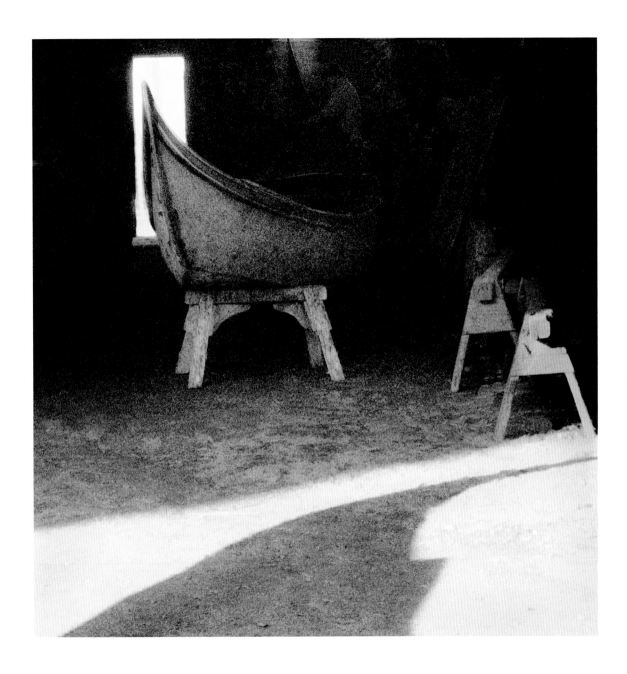

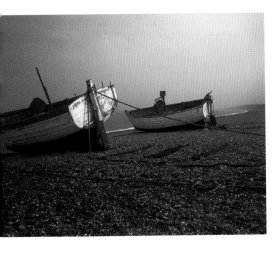

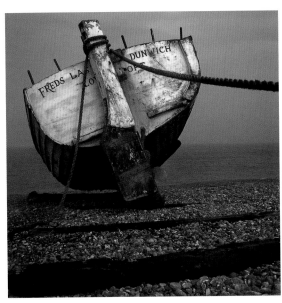

Let the accident participate.

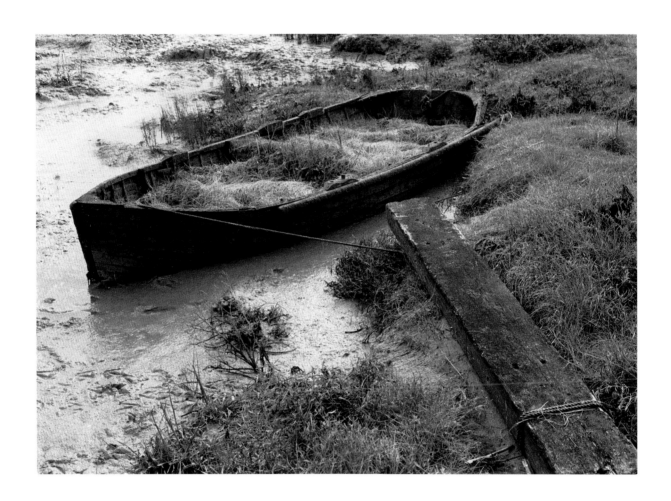

See ...

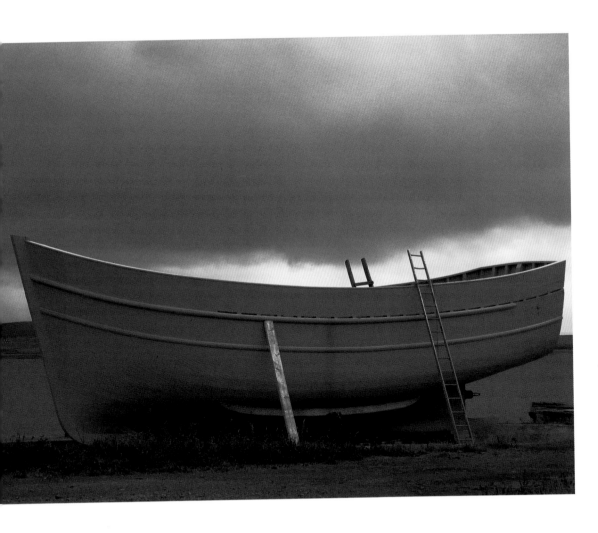

... don't just look.

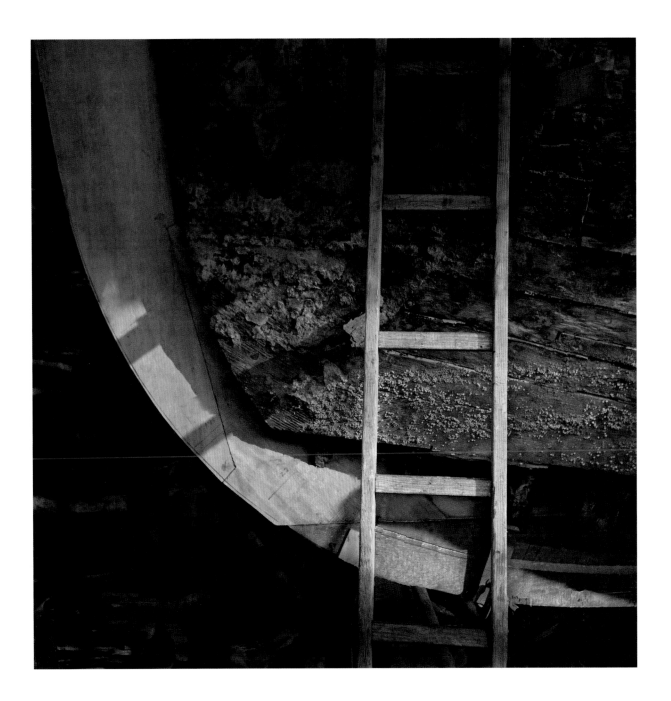

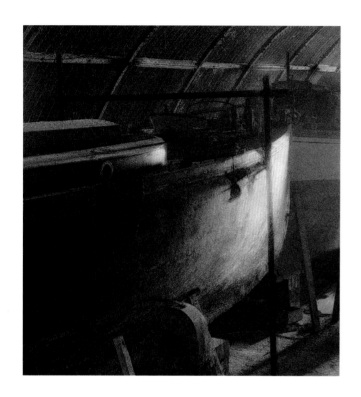

Complex yet simple.

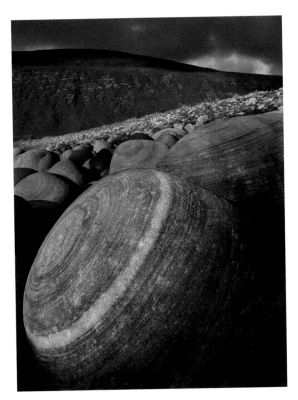

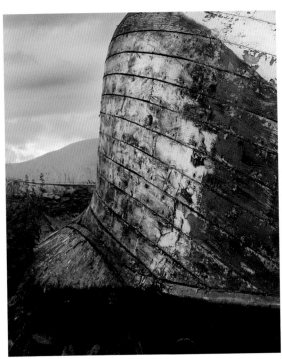

Experiment ...

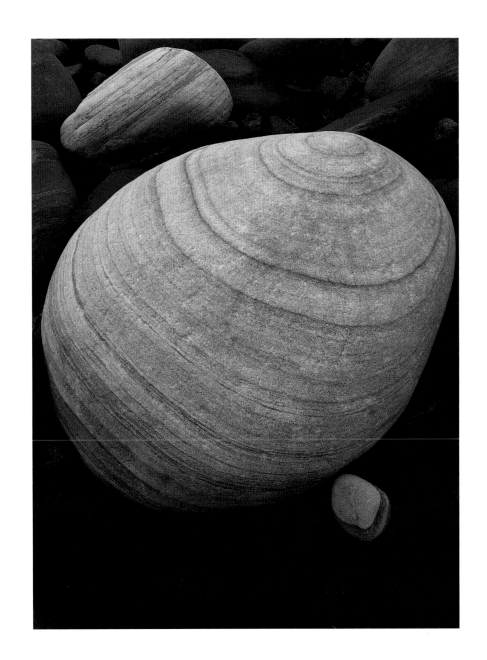

... then edit.

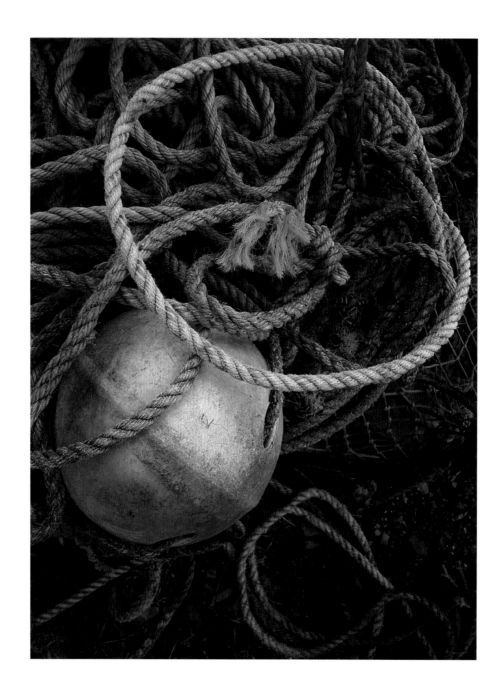

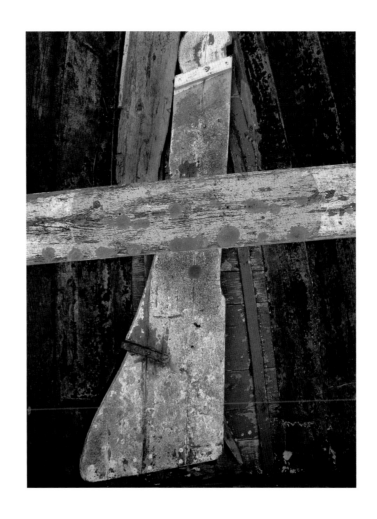

An image in everything.

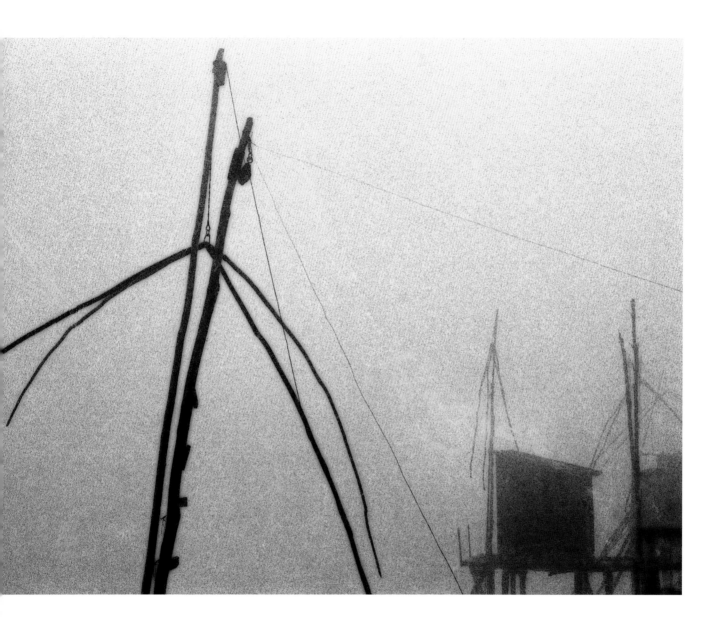

It's all in the printing.

Choices, choices

... setting up for digital

The workstation.

A 16-foot caravan in the country was my last-but-one darkroom. With its shuttered windows it was the closest I came to having a darkroom with a view.

What camera ... is it still a personal choice?

Should the subject, not the camera, determine picture quality?

Many photographers still work with large format cameras. In the digital darkroom, we too can compose the subject upside down and back to front – a great way to check print balance.

I like the idea of the camera as a companion, or the focal point of a daily meditation, or as a prism, helping to create order out of what I see. At times the idea of it as a retreat is also very appealing, but I always try to avoid putting it between me and my photography, as it were.

Like many photographers, I have an assortment of cameras: a couple of old Nikon F2s without meters, a Nikon FM2 with a wideangle to semi-telephoto lens, a meter-less Fuji 6x9 rangefinder, an old Linhof Technica 70 and a Hasselblad XPan. The most recent addition is a digital Coolpix 5000, while lately I've been at play with a Noblex 35mm panoramic camera, generously on loan to me. Most of the time there is a plastic disposable camera in the house, useful for those muddy family walks when jumping in puddles is *de rigeur* (my family graciously tolerates my childlike behaviour). And I am always switching between cameras, between computer and camera, and, as I have mentioned, between computer and watering can.

Can we tell which camera or cameras have been used to make the pictures in this book? If it's imediately obvious, and the first thing we notice about a picture, then either the content of the image or the way it is printed is clearly at fault. In which case, changing from one format to another, or from film to data cards, will make little difference.

Why have I recently bought a digital camera? Initially I purchased it to make small snapshots for an art-in-the-community book I was involved with. Using data cards would mean no film and processing costs. Later I experimented with the Coolpix, using it somewhat like a Polaroid camera to make some trial photographs for another photography book I'm working on. As I wasn't worried about picture quality, I made hand-held exposures, some of one or more seconds in duration. I was staggered by the results (a couple are included in this spread). This happy accident showed me how I could make the rest of the photographs – playfully, without pre-conceived ideas and without any concern about sharpness or camera shake. It was a very liberating experience and one that has already begun to pay off.

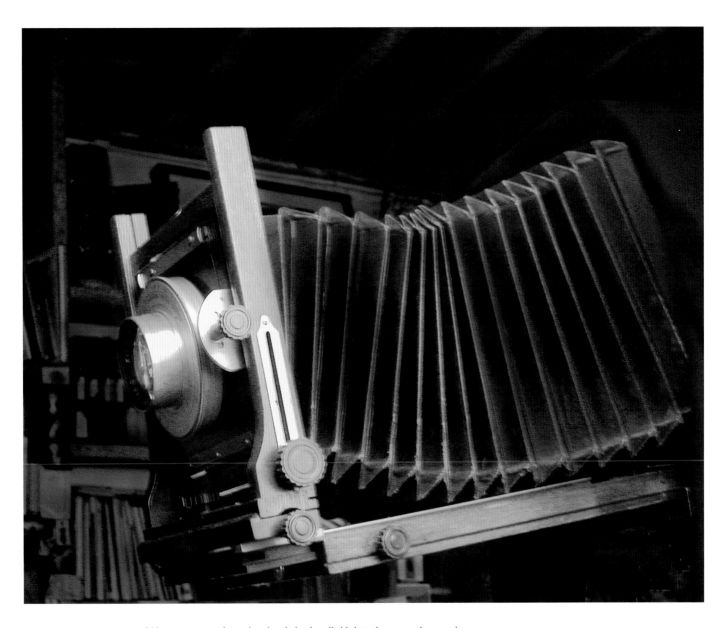

Old meets new in these ultra low-light, handheld digital camera photographs of an old Eastman Kodak lens and 10x8" camera. Even with exposure times of one to two seconds the pictures are surprisingly sharp – if that matters.

Film or data card ... grain or pixels?

Is there a case for both the old and the new?

Despite its age, and the business of having to process it, film is still the preferred medium of many photographers – myself included. Processing problems, like the occasional 'half-moon', haven't put me off using it.

I love the smooth, well-oiled sound of my film scanner as it gracefully pulls in the film holder. Placing the negative into the sleek, flexible, stainless steel unit, and feeling the scanner's magnetic holder drawing it smoothly into place, is just about as close as one could get to putting the negative holder into a really high-quality enlarger. In my experience the comparison ends there. With its cunning, yet simply curved film holder, the Imacon always holds flat that part of the negative which is being scanned, at the same time keeping it parallel to the lens/CCD plane. How many enlargers I have worked with have done the same? Gone are the days of negatives popping mid-way through exposing a print. With a scanner, I can still use film and really enjoy using it.

As well as working with film, I often use my little digital camera as a preview tool – a kind of Polaroid, but without the gunky, slithery mess of a sodium sulphite fixing bath, or, for that matter, without the on-going expense of film. Once satisfied with the composition I may switch to a film camera to make the final exposure. However, I've been caught out with this technique. A quickly seen and unselfconsciously composed image made with the digital camera often has a more natural quality to it than the film version which is seeking to copy it. In which cas, I might revert to my initial digital image and print from that, rather like printing from a Polaroid negative. The spontaneity of the moment seemed to be captured best in that version. However, the digital file can only be enlarged to a limited extent: time to get a 'bigger' digital camera? What, more gear?

Digital cameras offer all sorts of advantages: different films in one 'roll', the same depth of field with much larger apertures (useful in low light), and both an image preview and instant review facility, whereas with traditional cameras we have to rely on visualization, unless we use Polaroid. Arguably the direct involvement of traditional camerawork gets us more in touch with the subject, but does it get our photography more in tune with the intended result?

Once the decision has been made to use a digital camera, for anything other than casual snaps, I will normally set it to RAW mode. Unlike TIFF or JPEG mode, RAW doesn't colour manage the picture or apply unsharp masking, usefully leaving all those decisions to later.

My favourite 35mm film is Ilford Delta 3200, processed in PMK pyro. Recently I've experimented with colour negative film, as it can be camera-filtered in the computer. For 120, Ilford FP4 Plus remains a firm favourite.

Negatives contain an 'infinite' amount of information and are not limited by how much they can be enlarged. My small RAW image files have so far restricted my digital camera work to modestly sized images for books like this.

Digital darkroom gear ... state of the art?

What equipment do we really need?

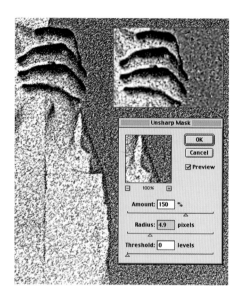

Through much practice, I find I can now print to a rhythm, working without consciously thinking about each step – similar to how I worked in the traditional darkroom. Back then the sound of a simple wind-up darkroom clock, or the ticking of a metronome, guided my print exposure work.

The answer would seem to be none, or so I thought as recently as the year 2000. Back then I wrote in *Ag photographic* magazine: 'I can state quite categorically that all the effort of making a darkroom, of working in one, of spotting prints and all the procrastination that goes into the image making process are, for me, what is missing in a relationship with a digital darkroom. I'll stick to my traditional chemical fare and replace the hair shirt of endless choice with a renewed commitment to traditional black and white.'

Then it was simple: tradition or change. Now I see that there is more to it than choosing between loyalty and divorce. Traditional black and white has given me my style of photography; and for that I owe it a lot, for sure. What a digital darkroom offers me is the ability to transform that photography. Through it I've discovered a new level of creative freedom that goes beyond the black or white choice of a marriage of obligation to silver or a union of convenience with digital.

Transformation has come through dialogue, as it always does. Through self-investigation and enquiry (much of it publicly, in articles I have written) has come the realization that, yes, I was committed to using the visual symbols associated with traditional black and white. But it would not constitute a betrayal if I switched to a digital darkroom. Quite the opposite would be true: if my commitment is to my photography first, then I must do what's right for it. Every day the evidence is there to confirm the switch to a digital darkroom has been the best thing I've done for my photography since I first entered a traditional darkroom.

Dialogue has brought a renewed clarity of purpose and with that I have been able to choose what digital gear I need. In retrospect these choices seem obvious, as they always do, but making them seemed so hard at the time. This is the list of gear that my photographic publishing work requires me to have: G5 computer with dual processor, a 22" CRT Lacie monitor, an Imacon 646 film scanner, an Agfa Arcus 1200 flatbed scanner, an Epson 1290 printer and a 20gb back-up hard drive. This level of sophistication is not necessary for producing just the simple kind of images seen here. Indeed a number of the pictures have been made with my Arcus flatbed and printed with an old laptop, using test-strips to monitor final print quality.

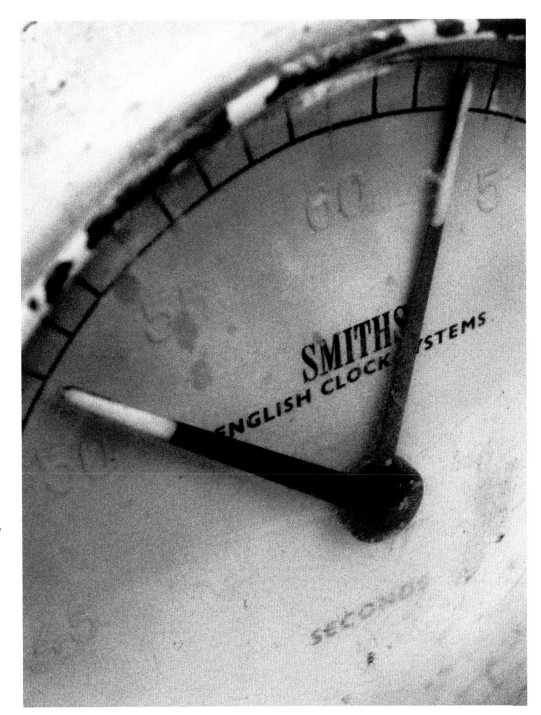

Opposite, scans from an underexposed, pyro-developed (tanned) negative, both of them over-sharpened in Photoshop to show how a flatbed scanner (inset) can't match a bespoke film scanner like Imacon's 646.

Which media? ... choosing a paper and inkset

How a paper feels can be as important as how it looks.

Remaining Ink level
There is enough black and color ink remaining to print over 100 pages like the last page printed.

Like most people I first printed digitally with a generic colour inkset that sometimes did horrible things to subtly toned prints. Now I'm getting great results with Lyson's Small Gamut inks.

Touch has always played a surprisingly important part in my photography: feeling for the smooth matt emulsion surface of Multigrade paper, to get it the right way up in the enlarger easel. This was always a tactile experience and something of a darkroom ritual. The same went for loading sheet film into dark-slide holders: there is nothing like the contrasting experience of having one's hands in the darkness of a film changing bag and at the same time enjoying the view from an open-top car, parked down an idyllic Normandy lane. Nothing too can match the panic that came with that experience, as I realized what an Englishman with his hands in his lap must look like to a couple of passing farm workers. Worse was to follow as one of them returned before I had loaded all of the holders ...

When I look at photography books, those I'm especially drawn to are the tactile ones (other people seem to go for the smell of fresh ink or the musty aroma of wood-free paper, just as there are those who love the smell of traditional hypo fixer). Through touch I can tell immediately whether I'm going to love a book or merely like it. The same can be said of photographs. If the paper they are printed on isn't sympathetic to the aesthetic requirements of the image then it kills that photograph for me – totally. With this in mind I have been careful to choose a paper that is right for my transition to digital (it must be both forgiving and tactile). At present I have settled on Lyson's 300gsm Smooth Fine Art. It is an archival matt paper, designed to work with their Small Gamut inks that I use. The only time I have ever used gloss paper was for lith printing, to give a stark, high contrast effect.

And inks? I love black and white books printed in duotone, or more expensively in sumptuous tri- or quad-tone, that have a glorious tonal range. Imagine then having the option to try for a similar effect at home, at a fraction of the cost, using a monochrome inkset like Lyson's Small Gamut inks (my preferred choice at this stage for printing toned images) and <duotone options>. Looking ahead, I can envisage a situation in which I'll have one printer loaded with Small Gamut and another, for pure black and white work, using an ink system like Piezography, that employs a carbon-based 'ink' for sumptuous palladium-like prints. Yet another printer (probably an Epson 2100) might be loaded with colour pigment inks for colour page proofs of books, and for printing archival artwork for artist-style books of my own.

Never was a cup of tea more needed than after a long session in the darkroom. I often used to judge wet prints while sitting comfortably in an armchair, cup of tea in hand, with the picture propped up in the darkroom door. This picture is not of my workroom, so perhaps I was not the only one who worked this way.

Setting-up ... colour management and profiling

Before I had a Colorvision screen calibrator, I used Adobe's built in colour management system. I found it adequate, but it does suffer from being subjective, having to be judged by eye.

Yesterday's problem of print dry-down is today's need for profiling.

I remember all too well the frustration of seeing the beautiful colour of sepia toned silver prints disappear as they were viewed in daylight. Conversely a gold over sepia tone print, carefully judged under a daylight balanced bulb, could turn into something hideously garish when viewed under more common tungsten lighting conditions. Where oh where was the <history> option or <colour balance> tool then? To counter such problems, I had both tungsten and daylight simulating viewing bulbs in my traditional darkroom; now I would add a third to the equation – a halogen spot lamp, given that it has become such a popular form of household lighting, especially in those areas where pictures are hung.

Trying to colour-manage work is a problem for digital photography too, though solving it need not be as complicated as I first thought. I tackled the problem from several angles: I acquired an excellent screen calibrator (the least expensive one, and surprisingly good at that) and I sought outside help, enrolling on a one-day colour management workshop that took a maximum of eight persons. It proved a great success – not least because it got me in touch with fellow sufferers, with whom many useful learning experiences were shared.

There was little problem getting the calibrator to work with my CRT monitor as long as I followed the very simple instructions. What I did find confusing was not knowing what to do afterwards. This was when I sought the outside help. Basically what I learnt about colour management was this: calibrate the monitor, give a name to the profile that the calibration software creates for the monitor, and assign that profile to the monitor using the <monitor control> panel. This is the only time this profile is used, although, as the monitor should be recalibrated every month, a new profile will regularly need to be generated in the same manner as the first. I date my monitor profile, so that I know how current the calibration is.

Next my scanner needed to be set up with Adobe RGB (1998) as the embedded output profile, found in its <preferences>folder. My scanner asked me to check various other simple settings. After this I set up Photoshop to run on Adobe RGB (1998), again using the <edit preferences> menu. All that remained was to download a Small Gamut profile for my Epson 1290 printer and follow Lyson's simple 5-step instructions for it.

The left-hand image of 'The Good Stuff' has an embedded SRGB 1EC61966-2.1 colour profile, as opposed to the industry standard Adobe RGB (1998) of the right-hand one.

The left-hand screen shot was taken before my monitor was calibrated, using a Colorvision Spyder. It shows a noticeable magenta colour cast. The contrast and brightness of both are quite similar.

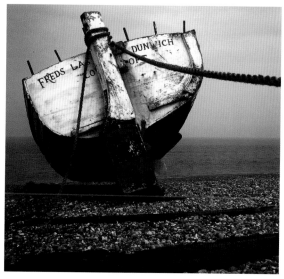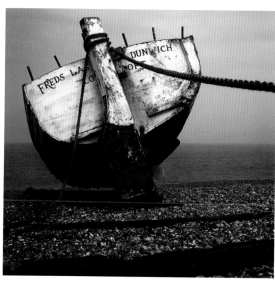

So far I haven't needed to get a bespoke profile for my Epson 1290 printer. But I may need to for untoned b&w prints, otherwise absolutely neutral images may be hard to achieve. It seems that some individual printer units require a customized profile, others not. Like buying a Friday or a Monday car, it's the luck of the draw.

The workstation ... *creating an inspiring place to work*

How much are we affected by our working environment?

How can we turn the digital darkroom into 'that' special place? Doing so will surely affect our printing – and for the best.

House to our memories, place to dream, inspirational space: separate from the outside world, and keeping all at bay with its flimsy black curtain for a door, the traditional darkroom had the makings of a transformational environment in which it was virtually impossible not to be touched by the hand of creativity.

In my first, none too light-tight darkroom, I used a rickety old wardrobe to unload my film. Stepping through the door was like entering the secret world of black and white, but it was a place in which I always kept my eyes tightly shut for fear of seeing those chinks of light hunting out my film. I remember hearing another photographer describe how she, too, used to close her eyes when unloading film – in her case while under her barely light-proof 'darkroom' duvet. We've all been there, in one way or another, and can anyone say that they have not been affected by the experience, even if their film did get a little fogged?

In his book *The Poetics of Space*, Gaston Bachelard looks at how we experience intimate places. There's a line in it about giant snails (of all things!) that got me thinking about how the darkroom became such a physical extension of myself: at times a place to retreat into, yes, but also an essential place that as a b&w photographer I always needed to take around with me in my mind's eye, so that I could pre-visualize how a potential subject might look once it too had experienced the magic of that darkened place. How can we manage without such a personal space – the shell that casts monochrome photography's rich black shadow? For me it would have been like seeing the world without the soul of the eye, to paraphrase a line from the same book.

Rituals are important. Photographic ones are essential. And darkrooms are great places for them. They help to separate our creativity from whatever else is going on in our lives, so that we can stand in that place and think of nothing other than the print. Nowhere is the need for ritual and the creation of a 'sacred' space now more important than in the digital darkroom. As it stands, most are communal places, often sharing mental and physical space with other people and various unrelated activities.

The symbols of ritual and craft don't just define who we are, they help shape our creativity. My digital workstation is surrounded by all sorts of personal items and pictures that I have a connection with. Apart from stimulating fresh ideas, I find they are a useful distraction, leading my eyes away from the screen for frequently needed rests.

Printing with digital

... my own simple working practice

Now my preference is for the <clone stamp>. However, I used to love the time spent retouching matt Multigrade prints (gloss was a different story). It was the ritual – signifying the completion of the print, more than the task of spotting, that I enjoyed.

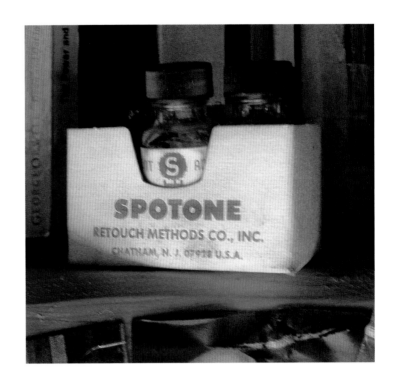

Which image? ... and deciding how to print it

The traditional approach is to previsualize the print before film exposure. I still do this, but playing with Photoshop enables me to discover other – often better – ways of composing a picture.

What do I want my printing to say and how can I achieve it?

I find it really helps to know the intended use for my prints before I start printing them: are they to be paired with others, as in the Gallery section, and, if so, will their balance be affected by the look and 'weight' of images placed next to them? Or, are they to be used singly, and if so, for what purpose – as an exhibition print, or maybe for reproduction? Such considerations affect my approach to printing, but should they dictate it? Sometimes I have found that a more expressive way of printing is through simple play, rather than the aforementioned, planned, approach.

Having a plan for the print also helps me decide on any cropping prior to scanning a negative, to keep its file size and processing time to a minimum, however I usually scan mine full-frame. This gives me the opportunity to experiment in Photoshop, to explore other potential crops (e.g. the cropped 'Goldtoner' photo, opposite), or to discover ways other than cropping to achieve balance, usually by altering local density and tonal values (p 102). Often this is a more subtle and effective way of getting a picture to balance properly, without spoiling the original camera composition, when I may not have noticed certain distracting details within the frame.

Sometimes I employ both cropping and tonal balancing, as in the adjacent example, also found on p 29. I cropped out the overly detailed right-hand side and then played with the tonal values of the print to get the composition to work around the hand, the cigarette and the smoke. This was done using <dodge> (to brighten the smoke, with it set to <highlights> at around just 4% for gentle control), and <clone stamp> (set at about 70), to remove the overhead and overbearing lightsource. Some local work with <burn> (on <highlights>) added the final touches to the table and to the arm of the chair.

How do I know when the print looks right? Always I will turn it upside down and back to front, using <rotate canvas> and <flip horizontal>, to see whether it looks balanced – more on this later. Also, I will check the image at different magnifications, both very small and large, and when an image is for a book like this, I will place it on its intended page to see how it looks when placed next to others. For example, one might be high, the other low-key. Are they unnatural partners? Or do they sit well together?

As I can't always predict the use for my pictures, I will often make several different versions, perhaps with a different plane of focus for each (top row), or with differering compositions, above.

What does a very tightly cropped version of this image now say? Only traditional darkroom workers might understand that the handwritten 'sod ca…' isn't a partial reference to an unreliable car. It refers to sodium carbonate! Cropped in this way, the picture lacks real meaning.

Opposite page: The contact print of the picture on page 29, which is captioned 'A time for reflection'. With this title in mind, I wanted the picture – simply – to have atmosphere, so I cropped out unwanted details.

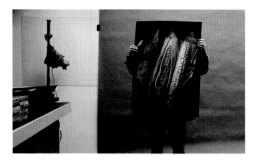

Here all four images are from the same negative, printed identically, but just cropped differently. Each version works for a potentially different purpose.

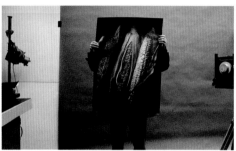

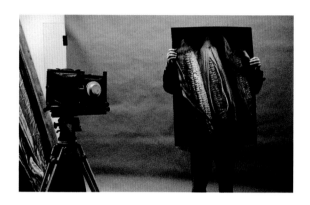

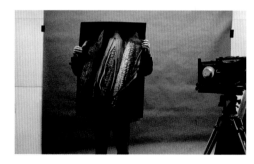

This is how one particular book publisher wanted to use this image, wrapped around a front cover: cropped, flipped and with a bright red logo. I declined the opportunity, despite the offer of a reasonable fee. I knew the print wouldn't stand the magnification required, the negative being underexposed and underdeveloped – not good for a book about art photography. Also, this was one of the few occasions when I've felt strongly about how a picture of mine was being used – badly, I thought. For a start, it doesn't work flipped.

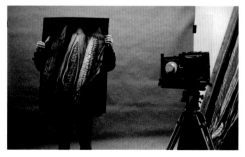

Subtle changes to camera position, cropping and/or print balance can completely transform the feel and meaning of an image.

Here two sections have been taken from the same image: one in focus, the other out. On their own they don't work so well – one needs to play off the other. I often get too much depth of field with my digital camera because of its 7.1-24.1 mm lens, even when the lens is set at its largest aperture. This is great for low-light work, but not good for pictures such as this.

How well would the 'Flea Spray' image on p 33 work if there was no shadow detail? For a start, the play on words between flea spray and potassium ferricyanide would be lost. Ferricyanide (a well-known photographic chemical) would read 'cyanide' and the message might now be one about hazards, rather than one that questions what role flea spray might play in a photographic darkroom.

Shadow depth is an important communicator. Printing a picture very high contrast, for dramatic effect, can work well, but it will often work better if one or more areas of shadow detail remain. The effect is to turn a stark, two-dimensional image into one with depth and complexity.

Depth of field and selective focus are powerful tools in the language of the black and white print. Even well executed, post camera, digital means of creating the same effects rarely satisfy the critical eye, demonstrating how sensitive we are to what is going on in a print.

Onto screen and into black and white ... *scanning negatives*

Do we scan our negatives as instructed, or is a personal approach better?

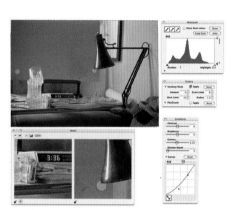

Experience has already shown me that scanning negatives is not an exact science. After trial – and much error – I've developed a system that suits my particular way of printing black and white.

I am so familiar with printing from negatives, and knowing how to read their potential, that I scan them to appear as negatives, and not as positives – the norm. There is another reason for this. When I scan in positive, I have a tendency to get the image looking as I think I want it, which often leaves it crucially short of workable detail in the shadows and highlights.

In the main screen shot (opposite page) you will see my normal scanning set-up. The 'histogram', 'texture' and 'gradations' windows are open. Sometimes I will open up the histogram to show all three colour channels. These can be tweaked to get more out of my pyro-developed, stained negatives, such as this one on Ilford Delta 3200. Later in Photoshop I will work in <channels> to see which gives the most grain-free image. Usually it is <red>, as it is seeing the tanned, grain-free part of the negative. Now that I have Photoshop CS, I scan everything in RGB 16-bit (per channel) mode, so that I have a larger file that will tolerate more manipulation, say in <curves>, before posterisation sets in.

Experience has already taught me not to scan using film scanning profiles supplied by scanner manufacturers. These profiles seem to want me to work both in grayscale and positive mode, and they usually make the image look quite different from how I want it. I find it better to use the scanner's own curves tool to get the appropriate density, contrast and tonal range. Normally I apply just a little unsharp masking at this stage, leaving the bulk of it until after I have done all my work in Photoshop, before hitting the print button. Sharpening at the scanning stage is irreversible and can affect image quality if I manipulate the print a lot. Like some other scanners, mine has the option to make RAW archive files. These can be altered after scanning without the need to rescan the negative – a technique I have yet to explore. As for dust removal, I use the scanner's own software, set fairly low so as not to lose sharpness. More on retouching later.

Recently I have experimented with colour print film, using <channels> to 'camera-filter' the negative, then saving it in 16-bit grayscale. In this way I get much more controllable effects (and reversible ones) than filtering in camera. For the same reasons I never use my digital camera in black and white mode.

My Imacon scanner has fairly similar controls to others, although it will produce larger file sizes than most – important should I progress to 20x16" prints or bigger. One of the tools I find most useful is the Detail window. With it I can preview up to four sections of the picture, at different magnifications and at different settings, to compare scanning effects.

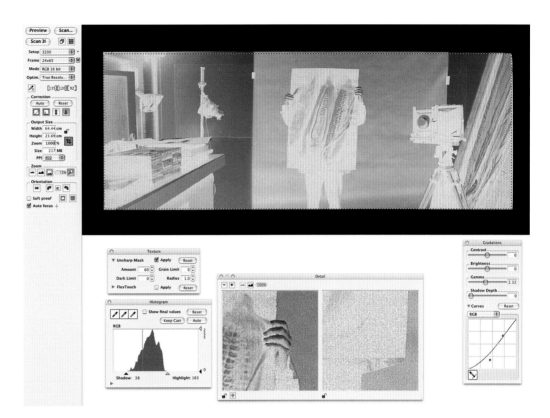

I open my RGB scans in <channels> to see which gives the best result. Why don't I scan in grayscale? With my scanner it is slower than RGB and I like to keep a full RGB archive file.

The more I scan the more I am learning about how best to expose and develop my film, while discovering which films work best. For the sharpest results I still use traditional silver-based films.

Exposure and contrast control ... <info>, <curves> and <levels>

Split-grade printing is far from dead and now we can do it much better.

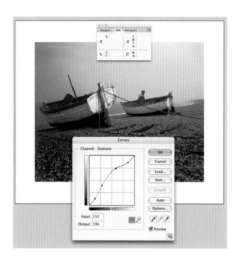

Traditional lith printing was an unscientific and unpredictable process, yet capable of producing exquisite results. Now, with <curves>, we can emulate its unique tonal range and control 'exposure' time with <info> and <levels>.

<Curves> is the equivalent of split-grade printing with variable contrast paper, only more controllable – much more controllable. As I'm sure you know better than me, <curves> can also be used locally when in <quick mask> mode, as on page 106. I tend to favour <curves> over <levels> for contrast control, for its potential subtlety. The angle and shape of the curve can be altered to suit individual image requirements. I might lock the lower, shadow end and pull the rest of the curve upwards to brighten the midtones. If this lightens the highlights too much, I will lock that end of the curve first (see adjacent image).

One of the most used tools in my digital darkroom is <info> (at the top of the adjacent image). Normally I have it set to 3x3 pixels, and use it to check how much density there is in key areas, say before and after, using a tool like <curves>. Later, by comparing these figures to printed test-strips (p 113), I can see the maximum and minimum amount of density that my paper/ink combination can hold above or below which detail will be lost, or become less well separated than I would like.

With traditional printing, the best enlarger exposure meters offered some degree of accuracy, but fluctuations in voltage and the variable nature of hand processing prints meant that really fine levels of control were rarely possible.

With <info> I can see just how much a 1% change can make to density and to tonal separation. Usefully <info> works the same in <duotone> so I can monitor the contrast and density changing effects of different colour combinations.

For me, <levels>, far right, lacks the necessary subtlety for adjusting the tonal range of an entire image. However, it is can be useful for adjusting exposure, say if the scan or digital camera file are much too dark or light, and I sometimes use it in <quick mask> mode to adjust the brightness of a specified area.

The two upper left images, opposite, show the before and after effect of applying <curves>. The image on this page has had the upper part of the curve pulled down to hold in vital highlight density, for a lith-effect print.

The lower, near right image has had the bottom half of the post brightened, using <quick mask> and <levels> set to make it brighter but to retain the richness of the blacks. The effect is intended to layer the print, to separate the post more from the background.

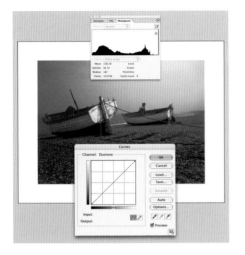 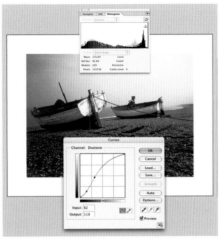 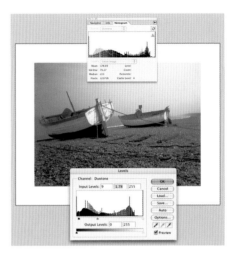

The lengthy process of making test-strips, to see how much exposure was needed and at what grade setting to get shadows and highlights looking right, is now a thing of the past.

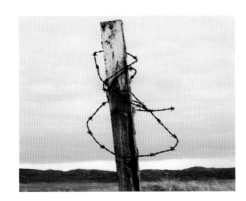 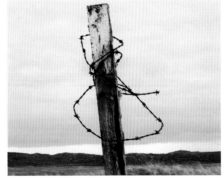

Achieving balance ... <crop>, <flip>, <rotate> and <canvas size>

What is print balance and how do we know when it is achieved?

Should verticals be portrayed vertically and horizontals horizontally? What are the rules? Do we make our own?

When I strive for balance, what I am aiming to do is set the picture free from the obvious signs of process, or failed process, and take the viewer's eye on a continual journey within the picture, inviting him or her on an endless game of look-see: look, see, look – SEE.

I have found surprisingly little written on the subject of balance, even less on achieving it with black and white digital printing. This is surprising when I consider the breakthrough that Photoshop offers us in this important area of self-expression.

Using <crop>, <flip>, <rotate>, <canvas size> and <zoom>, we have the ability to explore at the click of our mouse the full potential of a print: see it shaped differently (cropped to tell a different story), flipped (to give a different version of that tale and to see how the picture is composed), rotated (turned on its head to see if its shades of dark and light make a satisfying form, i.e. an interesting black and white print), and placed against a white backdrop (canvas size) to see how the picture will look later after it has been turned into a print and framed in a white matt.

With the above tools, I can tell in an instant whether a picture works as intended. A few moments later I might sometimes see new possibilites in it,

revealed by viewing the image back to front or perhaps upside down.

These tools can contribute to the making of a well-balanced print – one that tells the intended story, that makes the viewer feel connected to what the photographer is trying to say, whether it be a gently framed still-life, a rolling landscape, a mysterious and secretive abstract or a confrontational close-up portrait. However, they are no use without the vital ingredient of personal judgement.

And how do we know when a print looks balanced? Sometimes I look away from it slightly: does something unintended about it catch my eye? If I cover up that part with my hand, does the image now appear more at ease with itself? I will <flip> the print if I'm unsure. And always I approach photographic printing as an artist would a blank canvas – not putting in anything that doesn't serve a purpose. If it will confuse people then I'll take it out, either by cropping or using <clone stamp>.

With digital we have the potential to be surprised more than ever before, and to see how much extra a picture of ours may contain. Also digital tells me (rather too often) when a photograph I have taken doesn't work or isn't balanced. Still, this does save me a lot on printing paper!

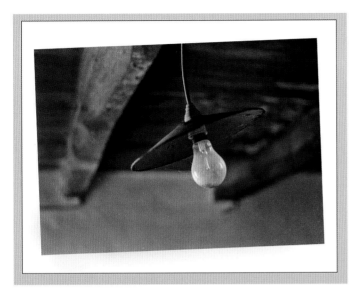

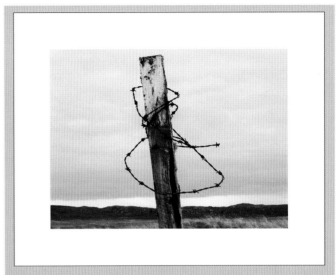

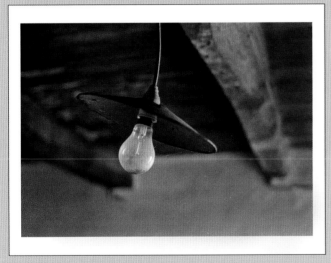

Top: by rotating the print, the lamp hangs at even more of a strange angle and yet it still looks natural because the bulb bisects an almost horizontal line. Bottom: a flipped version used to check balance.

These two images show how much brighter print highlights look, relatively speaking, when they are surrounded by a grey canvas. I always print with a white surround, created in <canvas size>.

Retouching ... <clone stamp> and <noise filter>

How much retouching is enough?

Highly accurate Photoshop tools like <clone stamp> help me in my efforts to produce prints that are as close as possible to how I feel about the subject.

In the past, enlarging my 24x36mm negatives up to 20x16" exposed all the dust and scratches. The way I dealt with this was two-fold: i) use a diffuser enlarger, or, in extreme cases, a cold cathode, and ii) retouch (spot) the print. However, soft lightsources affected the sharpness of highly magnified 35mm negatives, (where was the <unsharp> mask?!), while retouching was often tricky, and had to be repeated for each print.

Despite the time it could take to spot a print, I usually went beyond removing the evidence of poorly filtered wash-water or badly stored negatives. As a rule, I would retouch details that didn't 'belong'. How would I decide whether they stayed in or out? Spot the print upside down. With <rotate canvas> I do the same, so the picture is merely a collection of shapes and tones. If something catches my eye, I will remove it. If I'm unsure, I'll turn the print upright: does it affect my 'reading' of the print, e.g. a speck (rather like a full-stop . in the wrong place), or a distracting highlight (like an incor<u>rectly</u> underlined piece of text)?

A problem with traditional spotting was deciding what to remove at the enlarger stage and what to leave until the print had dried, by which time it was too late to burn, dodge or bleach the problem away. It was hard to see such details in a wet, swollen print, so a lot went unnoticed, and much time was spent later with a 000 brush and pigments or dyes. It is all much easier with digital using scanning software like Digital ICE or Flextouch with my Imacon scanner. I may sometimes use <noise filter>,<dust and scratches>, and of course the <clone stamp>.

The negative of the print opposite is covered in firmly embedded dirt particles. Did I forget to use deionised water for the final rinse? Quite possibly.

I have experimented with various ways of dealing with this problem. My scanner's retouching software is good, but, like <noise filter> and <dust and scratches>, too much of it can significantly affect image sharpness, particularly with very granular negatives, like my Delta 3200's.

Just recently I have experimented with an unfamiliar technique – a simple one that Barry Thornton wrote about in his concise guide to digital monochrome fine prints. The method uses <dust and scratches> and the <history pallette>, and then with the <history brush> (whatever that is!) one can literally paint over the picture and remove dust marks at will. Like other methods it can affect sharpness, so I ran the brush over just the darkest areas and used <clone stamp> with a hard-edge brush for the remainder. Comparing the two prints I would say that this hybrid method works.

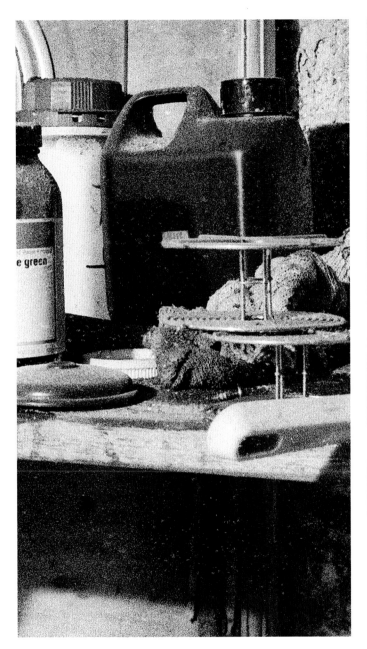

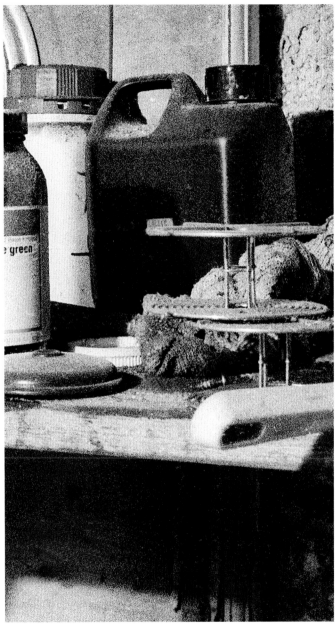

Before ... *and after.*

Local control ... <burn>, <dodge> and <quick mask>

Learning Photoshop is one thing, developing the confidence to judge whether a print looks right is another skill altogether.

Is there a difference between layering a print and just using <layers>?

Using a different paper grade (<curves>), altering print exposure (<levels>), applying simple localized exposure changes (<burn> and <dodge>), and using printing masks (<quick mask>) always did, and now does, the job of helping to create depth and structure in a print, i.e. layering.

To date I have managed to achieve all the layering I want – and more – without resorting to more complicated digital printing techniques, like <layers>. In digital, these simple tools have the added advantage of working even more precisely than their traditional equivalent, and their effect can easily be reversed.

Does this mean I'll never need <layers> or other more sophisticated digital tools? For my style of work it appears not.

It can be hard to choose, though, when, where and how much to apply the above controls to alter the layering of a print. This choice is made harder still given the enormous potential that Photoshop gives us to endlessly refine the image. If I was to critique my own Photoshop practice and give myself one piece of advice, it would be to set a limit to the amount of time I spend refining a print. And if I were to give myself another tip: limit the number of adjustments to each print, say to a dozen at most.

Within this limited <history> I would be forced to make bold choices and work with tools like <burn> set to what I would consider to be crudely high values (i.e. well over 4% for <burn> and <dodge>).

Control has always been a feature of my printing technique. I like to work on a print, searching for better ways of expressing what I want to say and hoping to discover new things to say. Most of the time this works, but does it only work within my known framework of printing?

On one level I know what I want my print to say (what the story is), and how I want to communicate this (through the printed 'word' of black and white), but breaking down the image into its component parts (its chapters), and then crafting them into a well constructed (layered) plot is harder. It takes practice. Looking at fine examples of b&w photography, and asking how they might have looked before printing, can help.

This page: in the top image the shadow side of the cap has been darkened using <burn>, with the brush set to <shadows>. The result is harsh, blocked and two-dimensional. In contrast the lower version has had the same treatment but with <burn> set to <midtones>, preserving vital shadow detail, giving the suggestion of depth.

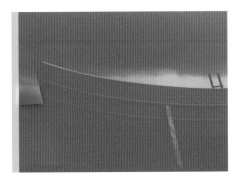 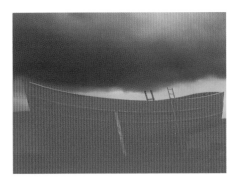

 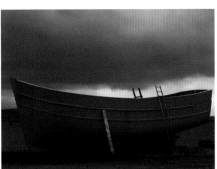

I may use <quick mask> to locally alter the brightness and/or contrast values of an image, as if I were working with variable contrast printing paper.

The screen shots show <quick mask> in operation with <levels>, to adjust the exposure of the unmasked areas. In the bottom left image the sky is now too bright, in the middle it is too dark, and in the right it looks as I imagine it should.

Technique books on Photoshop will explain much better and in more detail the kind of thing I did here; more important to us is to consider why – rather than how – to use such techniques.

For me <quick mask> is the digital equivalent of white card and scissors, used to create hand-held printing masks for burning-in or dodging silver prints.

Toning techniques ... *<duotone>* and *<duotone options>*

Now my concern is not how to tone but the real issue, why tone?

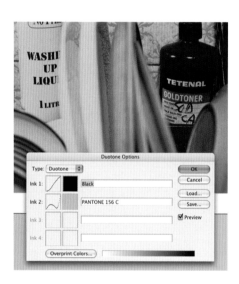

What better tool than Photoshop for experimenting with different toning effects – and what cheaper one? Once we have purchased it, we don't need to use any paper to see how an effect might turn out.

I used to tone almost all my traditional silver prints, to add the effect of colour-contrast, as they were on matt, more subdued looking paper. Despite the availability of split-grade printing, toning was still the best way to boost contrast, to give my grainy, flatter-looking, 35mm enlargements a vital lift.

The question is, would I still tone my prints if other means were available to get them looking as luminous as I wanted? The answer is probably not.

Well, now the means of better contrast control *is* available, mainly in the form of <curves>. This is Photoshop's answer to split-grade printing, only it does it much better, and well enough for me not to need more sophisticated digital tools or techniques.

The <curves> option is available in two forms: i) within <adjustments>, and ii) within <duotone options>. Using the former I can usually get my picture looking just right. However, the <adjustments> method applies a global, less refined method of change than in <duotone options>. With the latter I can alter *both* the curve of the black part of the image <ink 1>, and that of the colour I am applying <ink 2>. Just recently I've experimented with the <tri-tone>option, adding a second black and controlling its curve so that a little density

is added *just* to the darkest, shadow parts of the print. This is a similar technique to working with a traditional contrast mask. For example, typically I would make a second, very underexposed positive when making interpositives for platinum printing. This would contain just the darkest parts of the picture, which would significantly increase shadow density and separation when laid over the other full-range interpositive.

And what about the issue of whether to tone or not? If there were a follow-on to *Darkroom to Digital,* would I print the photographs in pure black and white? I believe so. This would certainly mark a change for me – another transition, from one way of working to another – or might it indicate a return to my black and white roots? Perhaps this is where my photography lives.

In many respects, black and white photography has come a long way since the days of chemicals and dishes. On the other hand, kitchen- or bathroom-based darkrooms have simply been replaced by office- or even bedroom-based digital darkrooms. However, the digital darkroom is a less hazardous place to work, and a big improvement for that.

What remains the same, separate from concerns
about whether one method of print-making is
better than another, is the effectiveness of b&w
photography as a medium itself. For me, toned or
untoned, it is the means to my self-expression.

Do I have a systematic approach to choosing a tone, or combination of tones, for a particular image? Yes, I consistently act on an intuitive sense of what is the right colour or combination of colours.

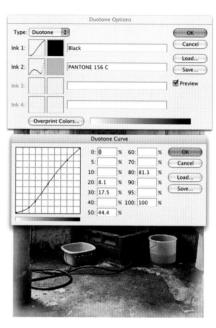

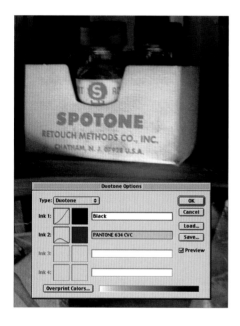

I have tried different ways of emulating black and white toning: <colour balance>, <hue and saturation>, and <filters> in Photoshop CS, but none give me the degree of control or choices of <duotone options>. Not even <colour balance>, with its <shadows>, <midtones> and <highlights> settings works as well.

Left: this picture was toned using an old version of Photoshop – 6.0. As far as I can tell, <duotone options> works just the same now with the latest CS version.

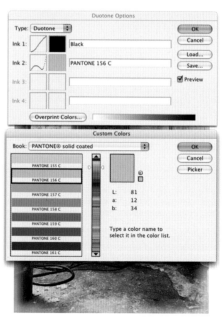

Printing with pigment-based inks, we can also now reproduce non-archival toning effects, like blue, to archival standards.

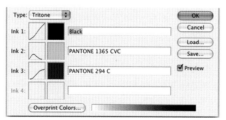

Right: using <duotone curve> and <duotone colour> to emulate a split-sepia tone. Multiple toning can be achieved with <tritone>, above.

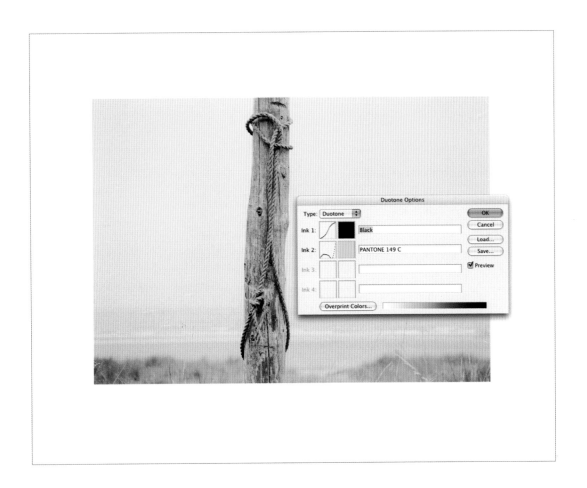

I suspect I am still of the opinion that the addition
of colour steers the mood of a picture in a direction
that makes its meaning more accessible to the viewer.
Put another way, I could say that my photography
still lacks the necessary skill or vision to find a way
to do this without toning. Will printing with
Photoshop help me discover a way?

Preparing to print ... *<unsharp mask>, test-strips and mistakes*

Although visible to the eye, the screen images is still only a 'latent' print.

When do I apply unsharp masking and how much? Normally I use a very small amount when scanning, the rest I apply just before printing out the image file.

I often forget that the picture on my monitor is made up of light and it is not until it is output using dye- or pigment-based inks that it actually becomes a print. With this in mind, the process of digital printing is not unlike that of the traditional darkroom, in which we have to visualize how the final printed image will look. This distinction keeps me firmly connected to my black and white roots.

For me, preparing to print is about what will help, at the final stages of Photoshop, to turn that image of light into a beautifully reproduced, ink-printed photograph. Much of the answer lies in <unsharp masking> and test-strips. How much unsharp masking I apply depends on how the picture is going to be used: for my 35mm images an average quantity might typically be <amount> set to 75 and the <radius> to 1.0 (as in the example, above left).

A mistake I made with my early digital camera work was to apply unsharp masking. Now I have a RAW image software upgrade for my Coolpix 5000, all sharpening and tonal adjustments can be done in Photoshop. Similarly, I have made the mistake of scanning my negatives with too much <unsharp masking>. It could prove a problem when doing a lot of work with <curves> and <duotone option curves>.

As a precaution, I make a copy of each image file before sharpening it and/or converting the <duotone> image to RGB for reproduction, as here, in books.

I've made plenty of mistakes while learning Photoshop. That's to be expected, but frustrating nonetheless. However, the biggest mistake would have been to ignore digital. Where would my photography and I be now if I hadn't decided to make the transition?

Even if I were to return to the darkroom, my confrontation with digital has got me to understand a lot. It has turned the light on in the darkroom, as it were, to enable me to see what I had been doing almost blind, under the subdued glow of the safelight, for so many years. I am thankful for that.

Most times when I make a digital print something still doesn't work quite as I expect, not through the fault of technology but usually because I am trying to use it in a way that makes it my own. Sometimes these mistakes work for the better and wonderfully unexpected results can happen. Other times I am left frustrated and my creative determination is challenged. But if a technophobe like me can make the switch to digital, then why not others?

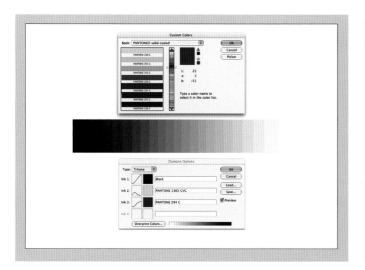

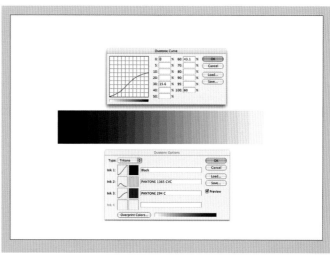

As in traditional printing, a good way to see (objectively) how different toners will work is to print out toned step-wedges. Here, I've created a sepia over blue <tritone> effect.

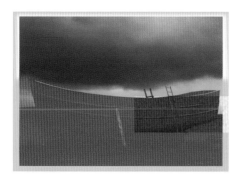

Occasionally things happen for no apparent reason. My expectation of digital is that – unlike traditional b&w – it should be problem free. Of course with <history> I can go back and correct my mistakes, but sorting out hardware or software problems is more difficult for me than, say, correcting a misaligned enlarger head with a wooden clothes peg for a wedge.

It would be fun to discover how many of the great photographs have come about by letting the accident participate. In the transition to digital, I've made plenty of mistakes and from them, already, a few prints that I'm happy with – it's early days.

Before and after ... *from negative or digital file to final print*

On reflection.

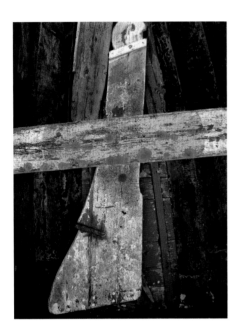

Why do I turn a beautiful, natural scene, full of nature's glorious colours, into a monochrome or toned b&w picture? The challenge is somehow to portray it at a deeper or more personal level.

Sometimes I look at a RAW digital camera file, in all its colourful glory, and simply marvel at what is around me. So why do I want to tamper with it? Because, as a b&w photographer, it is my role to look more deeply, to get beneath the surface of things, and share what I discover.

Of course, as artists, what we see in something is a reflection (at least in part) of ourselves, and our photography is the mirror that can make that image visible, asking us who we are and what we have to say. Our pictures answer those questions, no matter how objective our photography might claim to be.

But if there is nothing new to challenge us and our image of the world, then how will we grow ? How will our photography move on? What new things will we have to communicate through our prints? Or will it be more of the same?

The transition to digital has challenged me in many ways, not least by revealing how the magic of the darkroom actually works, and getting me to accept that all processes, whether digital or traditional, are just tools – not ends in themselves, as traditional printing was for me for so many years.

I suppose now that I look at the before and after images on these pages, I am asking myself what they say, and the deeper question of who am I, creatively?

A friend recently wrote in his email, 'I can't really envisage myself as a jobbing photographer, but that doesn't necessarily make me an artist. Is it up to me or the audience?' Speaking for myself, the responsibility falls on me as an individual photographer to acknowledge who I am and not be swayed by people who will look at my work (some will, I hope), who may prefer, say, the colour original of the ship's rudder to my black and white rendition of it. That's their choice. But, even if there's only one person who prefers the toned version, who is prepared to nail it to the wall, then I've succeeded, not because I've wanted to convert people to my view, but simply because I've done what any artist should, which is to share my view, in my case through this book. As it happens, there is one person, at least, who does prefer the toned version. It's me!

Looking at the colour version of the rudder reminds that there is a 'real' world out there and that it's almost time to finish this book, pick up the camera, and enjoy taking plenty more 'before' pictures and making lots of 'after' ones as well.

An imported RAW file, viewed in <channels>, first in red, then in blue, and then in green. In <red> the patches of lichen are lost, in <blue> the central tourquoise shape disappears, and in <green> the lichen is too prominent. My choice was to convert all RGB channels into grayscale.

Before Photoshop, photography was photography – a skilful game of visualization, then wait for the print and see. With digital we play a different game – one of picture editing, as we review the image at every stage. If we combine the two separate skills of visualization and editing, we will grow creatively, but if one simply replaces the other, then what?

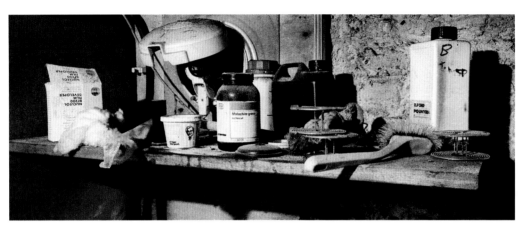

I used <duotone options> to create a variety of image colours, emulating a selenium toned chlorobromide print (above), a traditional warm tone chlorobromide print (adjacent), and a thiocarbamide, sepia toned print (opposite).

Which toned version do I prefer? What story does each tell? Does this picture work better big or small?

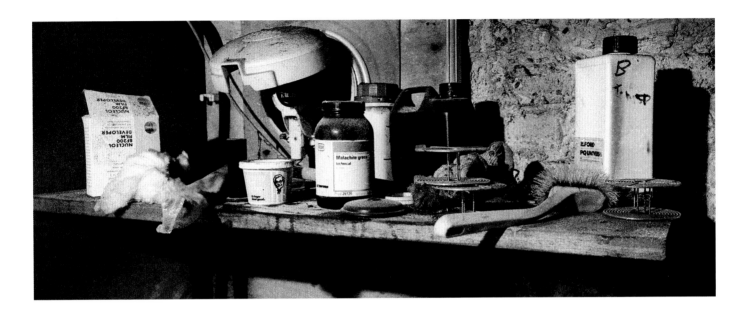

Does the meaning of a print change when it is used in a way that wasn't originally envisaged, such as on the all-important full-title page of this book? And has the meaning changed again with the addition of those screen shots laid over that image? I think so. This is why I design my own books – to explore new ways of seeing my photography and to find exciting ways of using it.

A conclusion

... the tradition of black and white is still evolving

What's new? With the arrival of digital, everything has changed, yet nothing has changed. The real issues remain the same.

Darkroom to digital ... *and beyond*

What next?

Looking through the journal I kept during the making of this book, I note that my initial concern about needing to learn complicated digital techniques has disappeared, to be replaced once more by an interest in the broader issues of creative b&w photography.

I started this book with a pre-conceived idea that it would be about combining techniques – darkroom AND digital (daybook cover, facing page). Soon this evolved into a book idea about switching techniques – darkroom TO digital, after which I discovered that the book *itself* seemed to want me to follow yet another path. Back then I couldn't visualize where that would take me; all I had was the pointer of the main *Darkroom to Digital* title to guide me.

How could I pre-visualize the final outcome and the full cover-page strapline – which would eventually include the key words *The Art of Transition* – without *first* going through the whole process of learning how to make black and white prints digitally? In a way this experience of letting ideas evolve parallels digital's huge potential for experimentation with photographs. Therefore, contrary to what some might believe (including me, not that long ago), digital takes nothing away from black and white. In fact, it only adds to what we already have.

Take the example of pre-visualization – the practice of visualizing the finished print prior to the camera exposure. We can still practise this, with or without a digital camera or Photoshop. But during the transition to digital I began to wonder whether the pre-visualization of 'old' might now be rather too rigid a process – another possible case of pre-conception. And to what extent is a pre-conceived way of working good for artistic growth? Sometimes, might it stifle it? If the '60s statement, 'we are artists, we have no taste' is anything to go by, now our dictum might be 'we are photographers, we have no pre-conceptions'. Traditional black and white is dead. Long live black and white.

Can I define what transition is? Do I know where it will lead me to next? Do I have a full title for my next book? Have I ever really known how a pre-visualized black and white photograph would *actually* turn out? I do know that the concept of the journey – whether it be the switch to digital, or the next adventure – should always be one of creative discovery, and that this search for the as-yet-unknown is a key element of all artistic endeavour, and that when it concerns personal growth, it will always involve transition. Part of the art of transition is about letting certain processes lead us. If we don't, and we stick to tradition, just for tradition's sake (letting it dictate the work's end

Darkroom AND Digital: *the cover of the daybook I kept from the time I started this book.*

In its pages I explored concerns and issues, as they arose, using the journal as a sounding board to discover where I was with my photography and how digital might influence or help shape it. Now my relationship with digital seems quite clear, but when I read back over my notes I am reminded of how different the situation once was.

The cover of my current daybook, Darkroom TO Digital ... and *(none too clearly)* beyond.

Like the proverbial blank canvas, the empty cover invites me to go beyond where I am now, to somewhere as yet unseen. When I finish writing in this daybook, I'm sure I will look back and be just as surprised at what I have discovered, as I am now, as I reflect on its predecessor.

In the traditional darkroom it was always said that the wonderful, luminous quality of a wet print could remain only wishful thinking. With digital such hopes can now be realized. What is there left to think about other than making pictures?

result) what possibility will there be for transformation? Personally, I would love my photography (and me) to experience continual growth and development. This may require me to face new and perhaps uncomfortable challenges along the way, such as my experience of the transition to digital.

There is no mystery to making merely technical transitions, such as to digital (as we already know, there are 500 plus Photoshop books that testify to this), but the *art* of making such a transition is another matter altogether. In my view, those of us who are making the switch to a digital darkroom might like to consider writing their own version of *Darkroom to Digital* (their own personal guidebook). Who knows what each might say? Of one thing I'm sure: we'll all end up with different straplines and I'd love to know what they would be. I know of one other – that of the late Barry Thornton, outlined in the acknowledgements page.

The distinction to be made here is that there is more to moving to a digital darkroom than simply getting a room with a view. As photographic artists, the transition to digital offers the potential of a room with a new view. What could be better? But what might that view be? Can we pre-visualize it? At the outset I certainly couldn't, but I did have a pre-conception of how I thought it would be, and how two-dimensional and horribly familiar that view was.

And finally, just as there are traditionalists who believe sailing is not sailing if there is an engine on board, so there are those who still see the introduction of digital as replacing the dog we take for a walk with a canine robot. We can chuck out the anchor and hold fast to tradition, or give up throwing sticks with the onset of technology, but far better to up-anchor or chase a few sticks ourselves. Who knows what the rewards might be? That's part of the fun of making the transition to black and white photography with Photoshop.

From the negative ...

It would be a mistake to think that having made the switch to digital the process of transition is complete. I like to think that the search for creative self-expression is an ongoing journey which I always want to continue – and with as little (technical) baggage as possible to weigh me down.

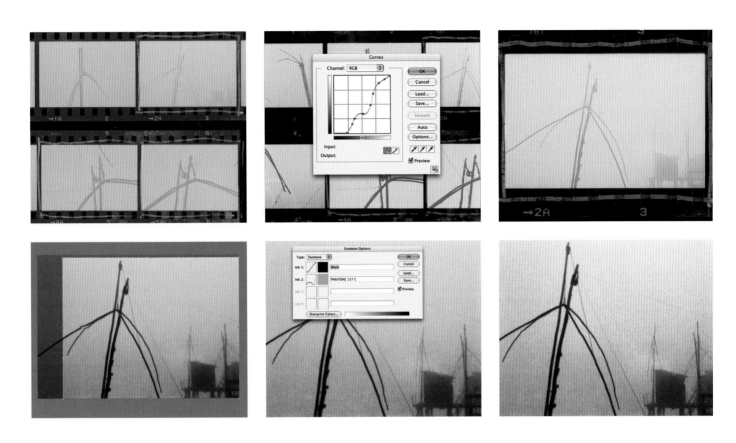

... to final print.

The process of printing black and white digitally is still remarkably similar to working in the traditional darkroom: negative, contact print, image selection, proof print, cropping, contrast control, dodging, burning and then toning.

Our transition to digital can simply involve a switch from one type of darkroom to another, or it can focus on issues of self-expression. Either way ...

black and white lives on.

Technical information ... *in brief*

Nikon FM2
Ilford Delta 3200
Agfa Arcus 1200 flatbed scanner
This was one of my first attempts at digital printing. I reprinted it recently and my approach was almost identical. Shadow detail is crucial to the success of this image: in the cap, under the handle and at the base. A little <clone stamp> work clarified the handwriting.

Nikon Coolpix 5000
RAW file
This was one of my first RAW image files. I love how the medium enables camera-style filtration in the darkroom, to alter tonal relationships and values. I used <quick mask> to select the clouds and to darken them as the backdrop to the post.

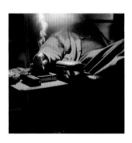

Nikon FM2
Ilford Delta 3200
Agfa Arcus 1200 flatbed scanner
Another early attempt. I made the mistake of dodging the smoke after toning, causing a local colour shift, akin to the irreversible effect of locally bleaching a traditional, toned print. Going back to <greyscale> and reapplying <duotone options> easily corrected the problem.

Hasselblad XPAN
Ilford XP2 Super
Imacon Flextight 646 Scanner
I wanted this image to have a lith-like quality, with high contrast shadows, low contrast midtones and warm peachy-coloured highlights, achieved through the use of <curves> and <duotone options>.

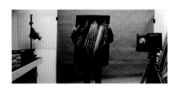

Hasselblad XPAN
Ilford Delta 3200
Imacon Flextight 646 Scanner
My first attempt at printing this under-exposed and under-developed negative was from a flatbed scan; it needed a far superior scanner. I dodged the giant corn and used <noise filter> to clean up the speckly shadows before applying <unsharp mask>.

Nikon FM2
Ilford Delta 3200
Agfa Arcus 1200 flatbed scanner
I had a go at reprinting this for the book, from an Imacon scan. Although the scan was superior I couldn't match the spontaneity of my original version. Also, I couldn't hope to print this in the traditional darkroom: a striplight has to be removed and the doorway tidied up.

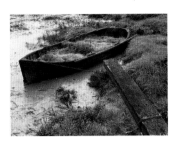

Nikon FM2
Ilford HP5 Plus
Imacon Flextight 646 Scanner
I remember well the sumptuous
quality of chloro-bromide printing
papers in the days when cadmium
could be added to them. The colour
of this print is a tribute to that era,
when I learnt the craft of b&w in a
self-taught, experimental way akin to
how I've learnt to print digitally.

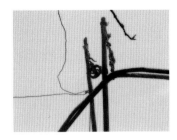

Nikon FM2
Fuji Neopan 400
Imacon Flextight 646 Scanner
One of several badly damaged
negatives that I couldn't hope to
print traditionally. Using the
<clone stamp>, with a hard-edged
brush, it was possible to retouch
large chunks of the image without
blurring the grain.

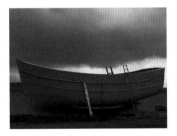

Nikon Coolpix 5000
JPEG file
Although not a RAW file, this jpeg
image is very good quality. Taken
quickly, before the cloud hurried by,
this full aperture, slow shutter speed,
hand-held exposure would have been
hard to make on film without a
tripod. Setting one up would have
delayed the exposure and the decisive
moment would have passed.

Nikon FM2
Ilford HP5 Plus
Agfa Arcus 1200 flatbed scanner
Another early attempt at digital
printing. I dodged the leaves one at
a time. Now I'd use <quick mask>
for a more uniform result. Using
<curves>, it was possible to
increase print contrast yet keep
subtle highlight detail in the chrome
– easier than pre-flashing a print!

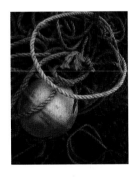

Nikon Coolpix 5000
JPEG file
This was taken a few minutes before
the photograph above, under overcast
skies, whose diffused light well suited
the image. I had fun arranging the
ropes and checking my composition
on the LCD screen, without the need
for Polaroid – a real bonus. The
digital file holds masses of shadow
detail, essential for creative printing.

Nikon Coolpix 5000
JPEG file
A two second, hand-held exposure in
low light created a pleasantly
softened image. I corrected the
downward-looking perspective with
<transform>, in the same way that
an enlarger easel can be tilted. The
high-key effect was acheived with
<curves>, using the <info> tool to
monitor density values.

The more I try to impose technique or my will on an image, the worse it
tends to look. It's when I print without consciously thinking about it that a
picture turns out best – the way the image itself wants me to make it look.

Acknowledgements

Many friends and associates have contributed to this book, and in all manner of ways. Each has played an invaluable role. In particular, my very special thanks are due to the following organizations and people:

Adobe Systems, Bodoni Systems, Linhof & Studio, Lyson, MWords, Studio Workshop and Silverprint, for material or much-needed technical support;

Paul Sadka for his insightful Foreword and excellent feedback on structure and content;

Piers Burnett and Bill McCreadie of Argentum, for the wonderful opportunity to make this book;

Angie Patchell for feedback on design and layout;

Ornon Rotem, fellow photographer and designer, whose regular cry 'I need your book' has puzzled me greatly – but challenged me very much for the best;

Phoebe Clapham and Terry Hope for excellent editorial work;

Joe Cornish for organising a much needed editorial break to St Kilda, where, apart from having a fun time taking photographs together, we shared ideas about our respective book projects;

Chris Dickie for the opportunity to develop my ideas through articles in *Ag photographic* magazine;

Tom Ang for patiently answering my naieve questions about digital. How he doesn't laugh, I don't know;

Lesley Aggar for her endless enthusiasm and humour;

Paul and Max Caffell, who are constant reminders that creative mastery – artistry – can be achieved even if one isn't naturally technically minded. It was Paul who instilled in me the guiding principle 'Let the accident participate';

Barry Thornton, whose transition to digital inspired my own move. Back in the early '90s Barry received a flier from me promoting my soon-to-be-released book called *Elements*. 'That's what I'm calling my book,' he phoned to say, and so mine was re-titled *Creative Elements*. Imagine then my surprise in 2003 to find out that we were on similar paths again, he with his self-published *Elements of Transition,* and me with *Darkroom to Digital ... the Art of Transition*. Very sadly he passed away before this book was complete or before he could publish an expanded version of his book with us at Argentum. It would have been great to exchange ideas;

Ruthie Morris – at one time a traditional b&w workshop student of mine, and now a self-taught Photoshop expert, whose transition to the digital darkroom, and mastery of it, really got me to question my own approach at the outset of this book.

A BIG thank you to my family, and especially to my parents for encouraging me to pursue my passions. And a special thanks to my wife Maxine and our daughter, Angelica. These two know how to laugh louder than most and make me laugh – important when you realize you've accidentally erased the last chapter of your book. And, thank you again to Angelica for keeping me on track, by all too frequently asking the question 'Wot you doing, Daddy?' A very good question indeed.